MW00780649

Acrylics Tips & Tricks

DAVID CUTHBERT

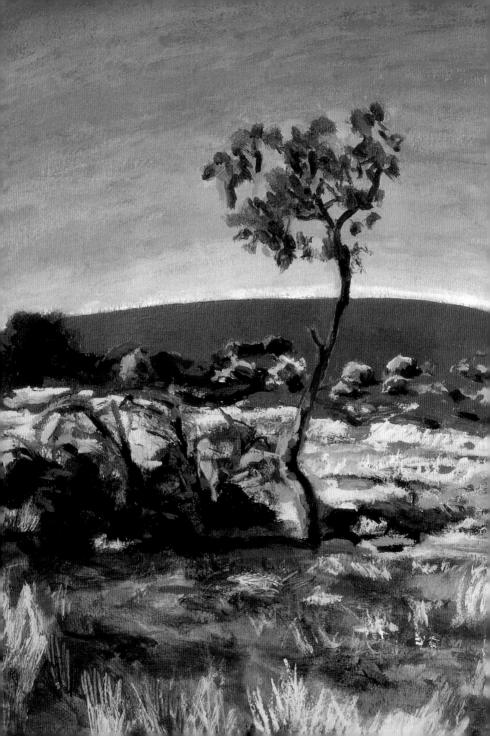

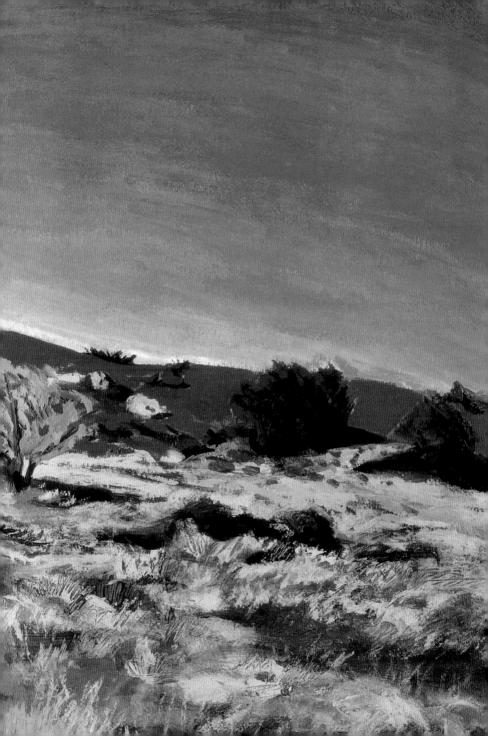

This edition published in 2009 by Chartwell Books, Inc., a division of Book Sales Inc. 114 Northfield Avenue Edison, New Jersey 08837 USA

ISBN-13: 978-07858-2438-1 ISBN-10: 0-7858-2438-3

QTT.TTA

A Quintet Book.

Copyright © 2009 Quintet Publishing Limited.

All rights reserved. No part of this publication may be reproduced, stored in a retrieval system, or transmitted in any form or by any means, electronic, mechanical, photocopying, recording, or otherwise, without the prior written permission of the copyright holder.

This book was conceived, designed, and produced by Quintet Publishing Limited, 6 Blundell Street, London N7 9BH, UK

Project Editor: Robert Davies Designer: Jason Anscomb Art Editor: Michael Charles

Managing Editor: Donna Gregory

Publisher: James Tavendale

The material in this publication previously appeared in *Artists' Questions Answered: Acrylic*.

Printed in China by Midas Printing International Limited.

987654321

Contents

Introduction	n	6
Key terms		10
Chapter 1	Basic concepts and techniques	14
Chapter 2	Understanding and using color	46
Chapter 3	Rendering still life	74
Chapter 4	Depicting landscapes	100
Chapter 5	Creating atmosphere and texture	132
Chapter 6	Painting water	176
Chapter 7	Portraying figures and animals	198
Index		222

Introduction

Acrylic paint is a modern medium that has been used by artists for about 60 years. It is remarkably versatile, fast drying, and durable, combining characteristics of such diverse painting media as watercolor and oil paint. Acrylic is also probably the most forgiving material to paint with. If you make a mistake or change your mind, you can paint over it after just a few minutes of drying time.

The pigments used in acrylic paint are the same as you find in other media, a combination of mainly earth colors and synthetic dyes. Acrylic colors are sometimes thought to be brighter than oil paints, but that isn't true. The misperception is caused by the fact that, because it dries quickly, acrylic color on your palette is not so likely to be muddied by other colors or by dirty brushes.

Another advantage of acrylic paint over oil is that acrylic does not crack easily. Oil paint takes about 60 years to dry completely, and changing atmospheric conditions can cause the different layers to shift and crack. Acrylic isn't likely to crack unless you use very thick paint mixed with other media, and then it will crack as it dries, not later. If you want the paint to dry more slowly—for example, if you are painting in the heat—you can add a drying retarder.

Brushes

Brushes come in many sizes. Although the numbering system varies from manufacturer to manufacturer, most range in number from 1 (the smallest) up to 12. Extra-large brushes (numbered up to 36) are also available. The ones above are sable brushes, which have soft, pliable hairs. See pages 16–19 for other types of brush.

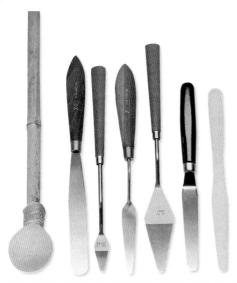

Palette Knives

Flexible palette knives were originally used solely for color mixing. But they can also be used in place of a brush, as a tool for laying on a thick layer (impasto) of acrylic paint. Additionally, knives can be used to scrape away mistakes or unwanted paint. The mahl stick shown on the far left is a tool for steadying your hand as you paint. You rest your hand on the stick instead of leaning on your painting.

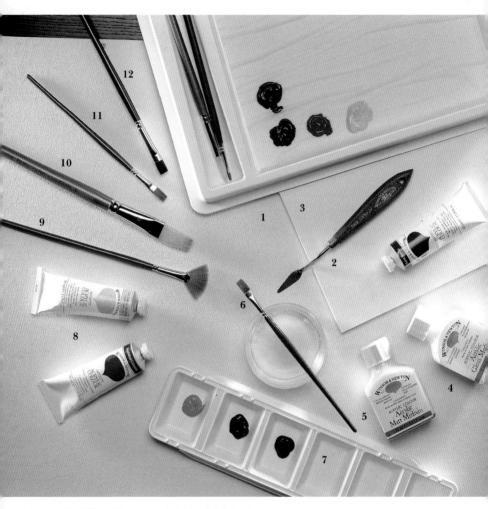

PAINTING EQUIPMENT

- 1 Mixing palette
- 2 Palette knife
- 3 Canvas board
- 4 Acrylic gloss medium
- 5 Acrylic matt medium
- 6 Flat hog bristle brush
- 7 Palette
- 8 Acrylic paints
- 9 Fan brush
- 10 Sable brush
- 11 Nylon brush
- 12 Pure bristle

A 4.4

The versatility of acrylic allows it to be painted on a wide variety of surfaces, both primed and unprimed. Oil paint should not be applied to unprimed canvas because the linseed oil in the paint and the turpentine used to dilute it will eventually rot the canvas. Acrylic can be used on canvas without any fear of rot, allowing a great range of application, from the palest stain through to the thickest *impasto*. Acrylic is also particularly well-suited to painting on watercolor papers, which is very useful if you want to work on a material that you can transport and store easily. There is even a specially formulated acrylic used for silkscreen printing; it can be used as a stenciling medium for handmade books.

There are wonderful examples of art made with acryclic paint in collections all over the world. The medium appeals to figurative and abstract painters; well-known artists who have used acrylic include David Hockney, Wayne Thiebaud, Jean Hélion, Andy Warhol, Morris Louis, John Hoyland, and Bridget Riley. But countless other artists are discovering the potential of acrylic, and the aim of this book is to introduce you to the fundamentals of working with this exciting and rewarding medium.

Key terms

Aerial (or atmospheric)

perspective—How the atmosphere affects the perception of distance, making distant colors cooler (bluer) and reducing contrast.

Alla prima—Italian, meaning "first time": when a painting is completed with only one layer of paint.

Complementary colors—Colors that lie opposite one another on the color wheel. Each secondary color is made of two primaries— the third primary is the complementary.

Composition—The arrangement of the subject matter within the frame of a picture.

Fat—Paint possessing a high proportion of oil to pigment.

Filbert—A brush, in the shape of a hazelnut, that tapers like a flattened cone.

Fixative—A sealant for pastel and charcoal drawing made from resin (traditionally shellac) and available in aerosol cans. It is best used out of doors to avoid inhalation.

Foreshortening—A perspective term used to describe an object appearing to diminish in size as it recedes from the viewer.

Form—The appearance of the subject—its line, contour, and three-dimensionality.

Glaze—Transparent film of paint over an area of color that has already dried.

Gradation—A gradual, smooth change from dark to light or from one color to another.

Ground—A layer of color, possibly with a texture, used as a base on top of which the rest of the colors are applied.

Highlight—The area on any surface that reflects the most light.

KEY TERMS

Horizon line—The true horizon is an imaginary line at the same level as your eyes. If you are on a flat plain, the horizon will be the same as the skyline. If you are looking at hills the horizon will be lower than the skyline.

Hue—The color value as distinct from its lightness or darkness.

Impasto—Paint applied thickly, so that the brush or palette knife marks are visible.

Lean—Paint containing little oil in relation to pigment.

Linear perspective—A technique of drawing or painting used to create a sense of depth and threedimensionality. Put most simply, parallel lines of buildings and other objects in a picture converge to a point, making them appear to extend back into space.

Luminosity—The effect of light appearing to come from a surface. Mahl stick—A stick with a ballshaped end which is used as an arm rest to keep your hand steady when painting.

Medium—The material or technique used by an artist to produce a work of art.

Negative space—The space around an object or between objects, which can also be used as an entity in composition.

One-point perspective—A form of linear perspective in which all lines appear to meet at a single point on the horizon.

Opaque—Something that cannot be seen through; the opposite of transparent.

Palette—A flat surface on which to mix paints.

Perspective—The graphical representation of distance or three dimensions.

Primary colors—Yellow, red, and blue are the three primaries. They are the colors that cannot be mixed from any other colors.

Proportion—A principle of design which refers to the size relationships of elements to the whole and to each other.

Resists—Materials that protect a surface from paint in order to maintain paint-free areas of paper. Paper, masking tape, and masking fluid are all resists.

Sable—Hair from an arctic marten that is made into a high quality brush, particularly suited to watercolor.

Scumbling—Where dry opaque paint is dragged across a layer of underpainting, to give a broken color effect

Secondary colors—Colors made from mixing two primary colors, for example, orange (red and yellow), green (blue and yellow), and purple (red and blue).

Sgraffito—Lines produced by scratching through one surface of paint to reveal the color underneath.

Shade—Color darkened by the addition of black.

Shading—The application of light and dark values that gives a two-dimensional drawing or painting a three-dimensional appearance.

Sketch—A quick freehand drawing or painting.

Spattering—A method of spraying droplets of paint over a painting using either an old toothbrush or a flat brush.

Sponging—Applying paint with a sponge to produce a textured surface.

Stippling—A method of shading that uses dots instead of lines.

Stretcher bars—A wooden frame on which canvas is stretched

Support—The paper, board, or canvas on which the drawing or painting is made.

Tertiary colors—Colors that contain all three primary colors. Brown, khaki, and slate are all tertiary colors mixable with varying combinations of the three primaries.

Texture—An element that refers to the surface quality or "feel" of an object—its smoothness, roughness, softness, etc.

Tint—A color to which white or water has been added to dilute and lighten the hue.

Tone—Without reference to color value this term refers to the degree of lightness or darkness in an area or an object.

Underdrawing—A sketch of the composition with pencil, charcoal, or paint that suggests tonal differences.

Vanishing point—The point on the imaginary horizontal line representing eve level where extended lines of objects meet (in linear perspective).

Viewfinder—L-shaped pieces of card or other material that are placed together to form a rectangular shape, used by artists to frame a composition.

Warping (buckling)—The wrinkling that occurs to lightweight papers after wetting. The heavier the paper, the less warping occurs.

Wet-into-wet—A technique where wet paint is applied to an area where the previous layer of paint is still wet.

earning to paint with acrylic is an adventure. It is exciting to master the various tools and techniques for capturing the essence of objects on paper, but, as with any adventure, the first steps can be frustrating. From early sketches to first brush strokes, however, each time you practice your art, your skills will improve.

To begin, you should experiment to see what the various tools can do. Pencil, charcoal, brushes, and many other implements—from a sponge to a toothbrush—will allow you to practice the art of applying paint. Fill sketchbooks with stroke exercises, color swatches, and experimental studies as visual training—learning to observe is a critical part of learning to paint.

Always be prepared to alter your art as needed, no matter how long you have been working on it, and feel free to capture only small elements of a subject until you feel confident enough to attempt the whole

picture. You do not have to draw every element of a flower in order to practice drawing petals. Also, vary the amount of time you allow for a sketch. Sometimes very quick sketches will teach you more—and be more successful—than lengthy studies. Begin with simple shapes—many complex objects are made up of a series of simple forms.

Do not feel the need to erase mistakes as a matter of course. Often seeing the way a line or color does not work is a good reminder of what does. If you find that you cannot capture certain objects, do not keep trying until you feel disheartened—sometimes practicing the way light falls on cloth can give you insight into the way light falls on hair or glass.

Most important, have fun with painting and drawing. The more enjoyable the experience, the more likely you are to relax and let the paint and tools teach you as much as any instructor could.

Types of brush

Each type of brush creates a distinctive shade, and the strokes of a brush can be thought of as its vocabulary. By exploring and learning the marks that each type of brush can make, the painter will be well equipped to tackle any subject. Brush strokes incorporate everything from the smallest dot to the broadest color field. It is not only what the brush is capable of that's important but also how the artist uses his or her hand and arm.

Holding a brush close to the ferrule will produce a cramped, restricted stroke. Allowing your wrist more fluid movement will produce longer strokes. Also, the farther

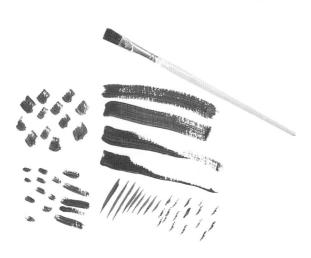

The flat hog bristle is a workhorse brush useful for blocking in color, but it can also be used to create a surprising range of strokes. Despite its square profile, the flat brush is capable of great variety, from broad swathes to light hatch marks. Most beginners find the versatility and control they can achieve with this brush a great help in mastering the early strokes and marks they need.

away from the bristles you hold the brush, the more expansive your marks will be.

Another consideration is how much pressure you apply to your brush. The lightest pressure will produce the faintest, most tentative marks; leaning hard on the brush so that the bristles spread or bend will give you the broadest and strongest.

artist's note

In order to explore brush strokes to their fullest, you will need to stand (or, second best, sit) at an easel so that you can use the whole length of your arm, as well as the hand and wrist for close work

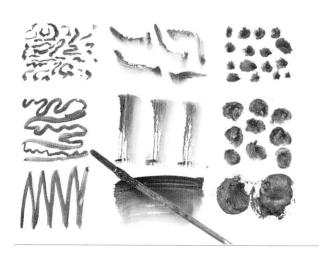

The fresco is a wonderful brush long-bristled, not too soft, yet pliable, and capable of creating fine lines from its point or broad strokes when used sideways. The brush holds the paint well and so does not need to be replenished as often as a short-haired brush does. Art stores will sometimes market this brush as a "whistler."

BASIC CONCEPTS AND TECHNIQUES

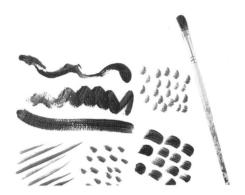

The filbert brush is named after the hazelnut because of its tapered, gently curved shape. The medium size used here does not hold a lot of paint, but it is excellent for close work with thick paint, as well as for making short strokes with thin paint.

Another versatile brush is the round hog bristle brush.

This is the next best thing to the fresco brush. It holds a good quantity of paint and—depending on how much pressure you exert—is capable of a range of marks from very fine to coarse and thick.

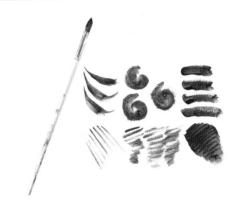

The rigger brush produces long, fine, flowing lines, but it can take a little getting used to, so practice making lines with it until you feel fluent. It is a good idea to mix the paint to the proper liquid consistency with another, stiffer brush—like a short-haired hog—before you use the rigger.

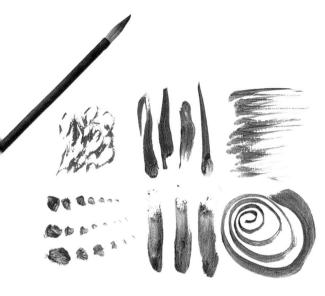

The hairs of a Chinese brush are much softer than the bristles of a Western artist's brush. Therefore, it can be used to make extremely fine lines, but it is not so well suited to working with stiff paint. It is best used with paint the same consistency as ink.

Nylon brushes provide a good point for fine work and can make a pleasing flowing line, as they hold the paint well. They are marketed for acrylic paint. However, if you are working quickly, the brush takes an inordinate amount of time to clean. You need to wash it properly, or the colors will become adulterated with those you used last. The second disadvantage (although the technology has improved in recent years) is that they do not wear well; the ends of the fibers tend to splay.

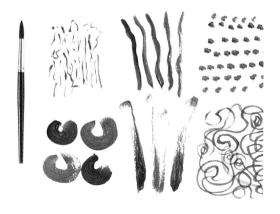

Applying paint without a brush

Brushes are only one of many ways to apply paint. From using fingers for sculptural effects to diffusers for fine sprays, there are several creative ways of applying paint to achieve textural finishes. For centuries, fine art painters have used their fingers to smooth paint edges and

Sponging

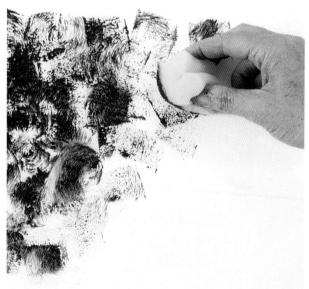

A cube of synthetic sponge cut from a larger piece makes a good implement for dabbing on color. The first dab will deposit paint thickly, but if you keep dabbing without refreshing the paint, the marks will become gradually softer and more textural. This technique is great for large areas of broken color, such as a woodland scene covered with fallen leaves.

APPLYING PAINT WITHOUT A BRUSH

remove paint. As far back as the eighth century, an artist named Zhang Zao was known for his finger painting and for using worn-out brushes to create special effects. Experiment with the following techniques to add texture and interest to your paintings.

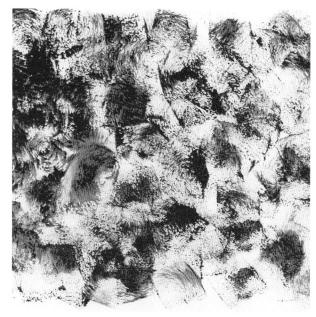

The paint applied reveals something of the sponge's surface, but it will respond to the texture of the paper, too. If you sponge onto a rough-textured paper, there will be more light holes in the dabbed marks. Sponging onto a surface that is already painted will produce another texture; the sponge will slip more, making sliding marks.

Spattering

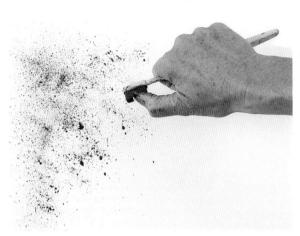

The spattering shown here is made with an old, stiff toothbrush. dipped into runny paint and then rubbed with the thumb to send a spray of fine droplets onto the paper. You need to hold the brush close to the surface of the paper if you want a density of color. The farther away you are, the more dispersed the paint droplets will be.

If you have strong lungs, you could also use a diffuser—a jointed metal pipe usually used for blowing fixative onto pastel work. It is good for covering larger areas with a fine spray of paint, and it is an ideal technique for creating sea spray. Paint must be the consistency of ink to work with a diffuser, otherwise it will clog the tubes. Generally, the spattering of paint is fairly even, but it is difficult to control, and you should practice on scratch paper before using it on a painting.

Finger painting

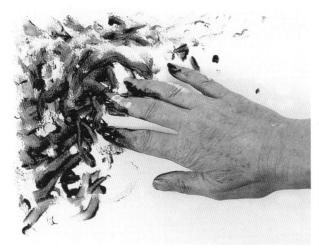

Fingers add a human element to a painting. The advantage of the finger mark is its immediacy: when you want a blunt, soft texture you can rub your fingers into the paint after it has been brushed on.

This technique is great for giving the impression of a mass of soft color, such as for seaweed clinging to rocks or a shaggy dog's coat.

Selecting the right format for your picture

Before you begin to paint, the format of your painting should be something that you make a conscious decision about, rather than just accepting the canvas manufacturers' shapes and sizes. This is particularly important when you are out looking for a subject in the landscape. Many artists bring along a simple viewfinder, an adjustable frame that can be held vertically or horizontally. This device will help you find the format that best suits your subject, as shown in the examples below.

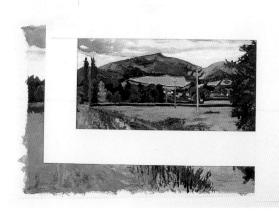

Here you can see that the original painting was a fairly wide "landscape" format. In this example, the viewfinder has isolated a "portrait" format, cropping the image, so that the diagonal of the river is a tight line broken asymmetrically by the two horizontal edges.

SELECTING THE RIGHT FORMAT FOR YOUR PICTURE

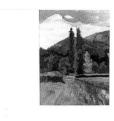

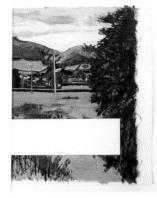

A much more stable and horizontal composition is selected in this more panoramic format. It is a much less dynamic composition than the "portrait" format. The hill sits squarely on the strong horizontals of the ground and the shadows, and the diagonal river on the left merely acts as a support for the central horizontal.

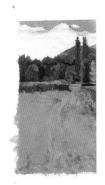

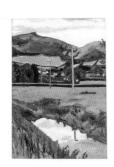

This "portrait" format traps a lot more foreground than the previous two compositions. Having such a large space in the front causes the hill to appear to recede into the distance and makes the water a real presence in the painting. When you are selecting your focal point, you have to decide what it is that interests you about the scene you are painting.

Choosing a sketching medium

Unless you plan to paint something very technical that requires a detailed drawing, it is best to sketch your composition with either charcoal or a brush and light, thin paint. These media create a more "painterly"

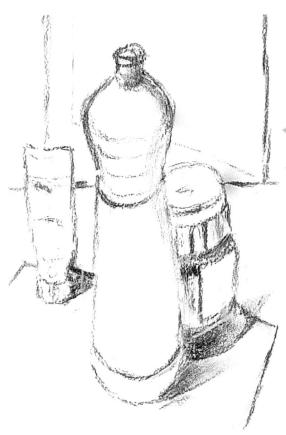

artist's note

If you are making an enlargement from a sketch, take care that you are not making the background bigger and the main space too small relative to it.

Quickly sketch a simple charcoal line drawing of the composition. Wipe off any mistakes with a clean, dry brush, but if you want a perfectly white surface where you have made the correction, you will need to apply a coat of white paint or primer.

approach and are less likely to encourage the premature shading in that can be a temptation when working with the precision of a pencil drawing.

When you are happy with the drawing, seal it with a coat of matte acrylic medium, applied with a soft brush. This will ensure that the charcoal does not dirty the color when you start to paint.

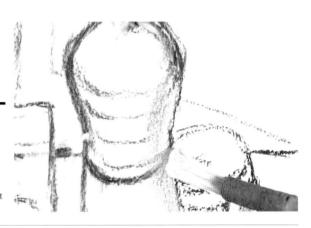

An alternative to using charcoal is to sketch your composition with a brush and diluted paint (see page 18). This will allow you to continue the painting uninterrupted from the sketch through the finished piece. Correct mistakes by painting over in white.

Using acrylic as a sketching medium

Acrylic is an excellent medium for sketching on location. The paints are water-based and therefore dry quickly, which is a huge advantage when working in a sketchbook. If you paint across both pages of an open

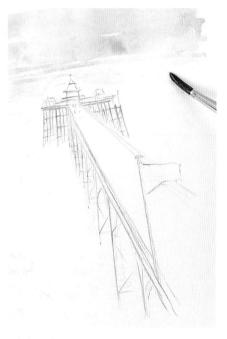

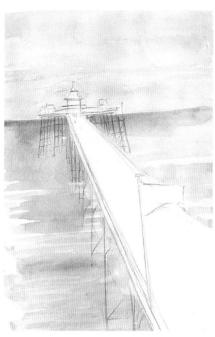

Although you can begin a sketch with an HB pencil, adding acrylics will remind you of the colors and atmosphere you'll want to recreate. Here, for example, a very thin phthalocyanine turquoise is washed into the sky to capture the brightness of the summer's day.

Professional for the sea, the same turquoise is used, but in a more intense mix. The pink in the sky just above the horizon is a very diluted red-violet. This same thin color is added to raw sienna for the sandy-colored strokes in the nearer parts of the sea.

sketchbook, put a sheet of tissue or plain paper between the two pages before you close the book. This will stop the paint from sticking to itself.

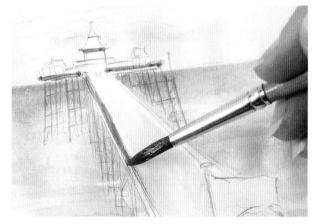

The brush strokes used for the decking of the pier are a pale mixture of raw sienna and red-violet. When sketching on site artists carry only a limited palette of colors, so the green of the edge of the pier is made from raw sienna and phthalocyanine turquoise. Both the palette and the brush strokes may be much more varied for the final work

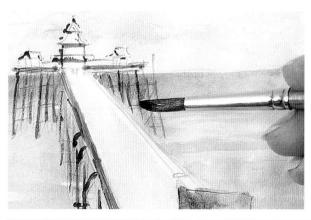

The finishing touches to a sketch can record extremely useful information for the eventual painting. For example, the sketch will highlight details, such as the Payne's gray and phthalocyanine turquoise iron struts of the pier, as well as the final additions of color, such as the diluted red-violet flag in the foreground.

BASIC CONCEPTS AND TECHNIQUES

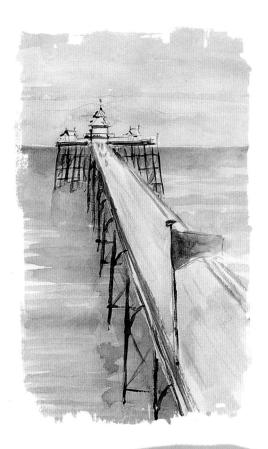

Left: This study was made in a small sketchbook—small enough to fit in a coat pocket—but it has a wealth of information for a finished painting.

artist's note

When out sketching, you won't want to carry a lot of weight in paint. Using a limited palette is more convenient and a challenging discipline. In this sketch, for example, only four colors were used. Ideal equipment for sketching on location includes a small bottle for water, a couple of brushes and a paint rag, and a plastic box for carrying paint tubes; you can even use the lid as a mixing palette.

Working on white and colored grounds

Pastel painters usually work on colored paper, choosing a color suitable for their subject. Watercolor painters paint on pure white paper in order to exploit the luminosity of their colors. Oil and acrylic painters can do either, depending on their subject and their approach. A colored ground is a launch pad for your color composition. Whatever color you put on next will interact with the base color—powerfully if it is a contrasting color, subtly if it is more closely related. Working on a colored ground certainly has its advantages, but you can work from a white ground and still create an impressive painting.

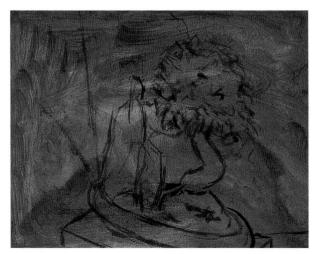

Here you will see how the deep ground color gives added impact to the colors of the finished painting and is used to subtle effect to create areas of shadow in the final piece. Start with an intensely colored ground of phthalocyanine blue. This is a transparent color that gives a lot of depth. Then draw the objects using Hooker's green deep hue.

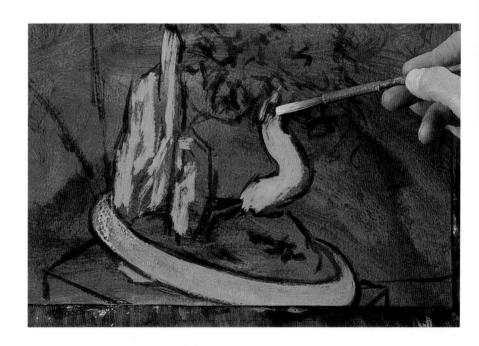

artist's note

Applying a colored underpainting provides a good ground to work on. If you use a dark ground, you can leave the color exposed to create shade and depth. If you use a lighter ground, the color can be used as light values and highlights, wherever it is left exposed.

Block in the objects' light-catching surfaces in a mix of Payne's gray and titanium white. Keep the painting simple so that you can exploit the effect of the blue underpainting. Here, the blue is left exposed on the trunk and the rock to create shading.

WORKING ON WHITE AND COLORED GROUNDS

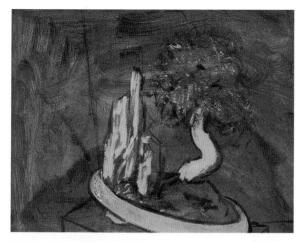

When the transparent Hooker's green and yellow of the leaves are applied, the blue underpainting will show through, giving added density to the greens. Where you want lighter foliage, paint with pure arylide yellow straight from the tube. Where you want the darkest greens, use Hooker's green deep hue. The leaves are not as stark as they might have been on a plain white background.

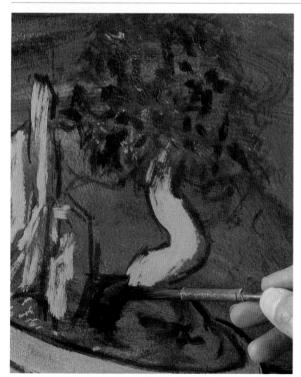

The moss at the base of the tree needs to blend with the greens of the foliage. But it should also be more solid and cover the blue background completely to contrast with the dappled leaves. Use Hooker's green deep hue together with Hooker's green.

BASIC CONCEPTS AND TECHNIQUES

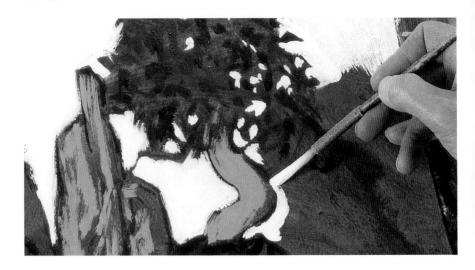

Now start to apply a mix of titanium white and unbleached titanium to the background. Notice that as you eliminate the background blue, the blue remaining on the rocks acts as shadow and will not need more color.

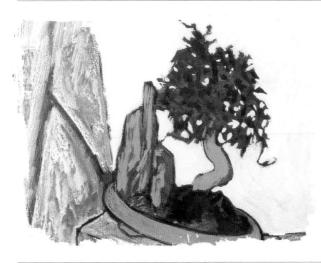

Using the same white mix as the background, scumble a thin layer over the drape on the left to give a broken color effect. Keep the surface of the drape and its three shapes quite rough as if to echo the form of rock. Leave traces of the underpainting where you want it to act as shadows. Notice that the underpainting adds a richness of color to what is a very restrained and simple color composition.

WORKING ON WHITE AND COLORED GROUNDS

Crimson ground
Here is another excellent
example of using a colored
ground. These anemones
were painted on a crimson
background that was then
toned down in the upper
half, bringing out the colors
of the flowers. Then it was
enriched with greens in the
lower half to push the jar
forward. The effects are
very different, but the unity
of color shows throughout
the painting.

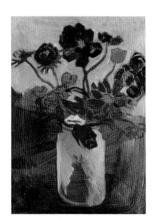

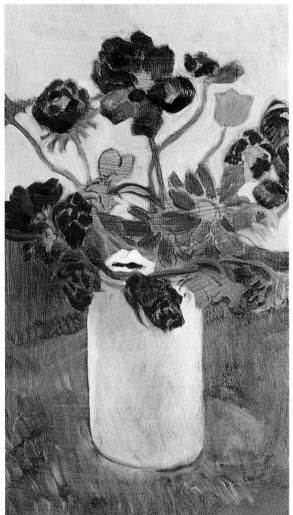

Making realistic shadows

Light and shade enable us to see form in space. Shadows give weight to an object and balance the light areas. It is a common mistake to paint shadows uniformly dark. In most shadows, there is a range of tone, and, crucially, the edge of a shadow will vary in focus from sharp to soft along its length. Light can also be reflected back into some shadows so that they have paler patches within the darker whole; sometimes one edge of a shadow is significantly lighter than the rest. Look carefully at shadows; they are subtler and contain more light than you might think.

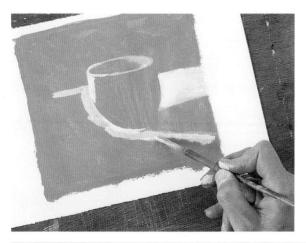

Consider the painting as a whole. Shadows are just one part of the way light plays on the subject. For this simple tonal painting of a cup, the background was painted a mid gray. The advantage of this ground is that it establishes the mid values; you need only paint the lights and darks. Because you can't rely on the white of the paper, the lights need to be blocked in using titanium white.

MAKING REALISTIC SHADOWS

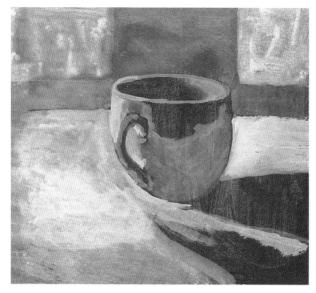

The thickness of the titanium white will affect the density of the light. The underpainting keeps the whites duller where you want them to be and more opaque where you want brighter whites. By carefully observing the variety of grays, the lights, and the little patches of reflected light within the shadows, you can make the object on the table look three-dimensional.

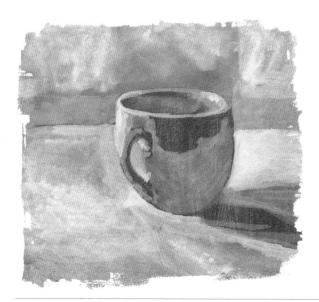

Notice that the shadow cast by the cup is neither all one tone nor simply a copy of the shape of the cup. Light leaks around the shiny ceramic surface and, on the shadow side, picks up reflections from the table. The final result shows the soft light from the window revealing the form of the cup and its smoky shadow.

Negative shapes

Negative shapes are the "glue" that holds a painting together. The spaces, or intervals, between solid objects are not often seen as having much importance, yet they are crucial to an understanding of pictorial space.

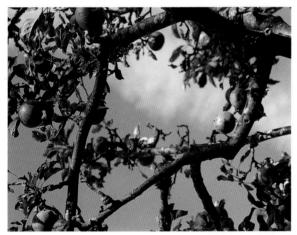

The shapes and patterns made by the overlapping limbs of the branches of a tree are an ideal source for seeing negative spaces easily. These spaces are immediately apparent as the bright blue of the sky against the darker, positive shapes of the wood, leaves, and fruit.

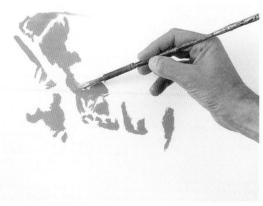

Without making an initial sketch, use a fluid consistency of paint, and gradually paint the gaps between the branches. This is a valuable exercise in close observation and precise painting.

Many painters discover that the spaces between things can be just as important and interesting as the objects themselves. When you begin to see the negative spaces as

integral to the whole image, you are thinking like a painter.

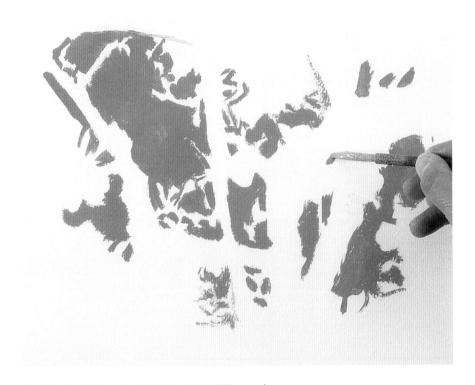

Exploring the spaces between the branches reveals a great deal about the nature of the apple tree. Where the branches overlap, the individual details of texture and leaf structure emerge.

Here you can see how convincing a painting using negative space can be in describing a subject. You can leave it as an interesting abstract piece, or complete it by painting the positive shapes of the trees.

Right: You can clearly see the human figure in this drawing, despite the fact that the only detail is in the areas surrounding the figure.

artist's note

If you are having trouble painting objects in proportion, look at the sizes of the negative spaces rather than those of the objects themselves. The negative spaces often provide added information on lengths and distances that might elude you if you simply study the objects in relation to one another.

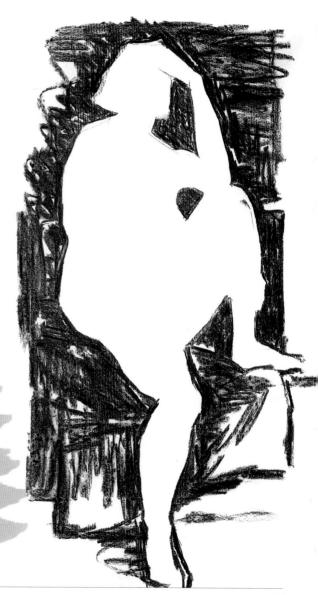

Perspective: the ground rules

A magical aspect of a painting is the way it can convince the viewer that it depicts space and depth. Breathtaking illusionism was achieved during the Renaissance because of a developing understanding of the laws of perspective. Linear perspective allows us to construct a drawing that creates the illusion of depth by relating everything to the horizon or eye level.

To construct a successful illusion of space, we have to invite the viewer into the picture field. The most effective way of doing so is to build the space around an eyelevel point or plane that the viewer can immediately recognize, the horizon line. The farther away objects are from the viewer—and the closer to the horizon line—the smaller they appear and the lines of objects appear to recede to a single point on the horizon line called the vanishing point.

After you have practiced applying the theory of perspective demonstrated here, keep it in mind when you are drawing. The knowledge will help you to judge the accuracy of your artwork.

PERSPECTIVE: THE GROUND RULES

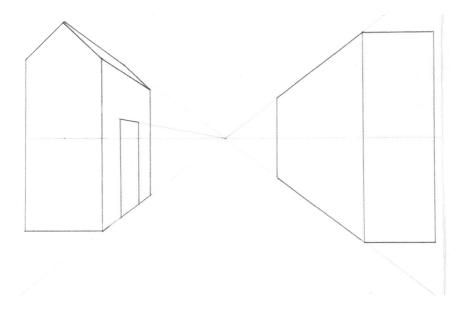

The simplest example of linear perspective is shown in this illustration of one-point perspective. The sides of the two blocks taper toward the vanishing point on the horizon. The higher or lower the horizon line is relative to eye level, the steeper the line becomes.

BASIC CONCEPTS AND TECHNIQUES

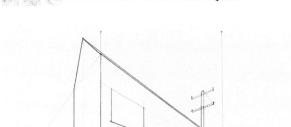

Two-point perspective allows us to see how two sides of a building at 90° angles relate to each other in perceived space. Now we have vanishing points for each side of the building meeting at two different places on the horizon.

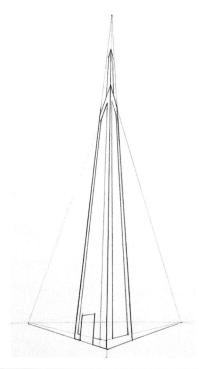

If you have seen photographs of tall buildings you have probably noticed that the sides seem to taper toward the top. This is three-point perspective, a useful device for creating a sense of immense height.

PERSPECTIVE: THE GROUND RULES

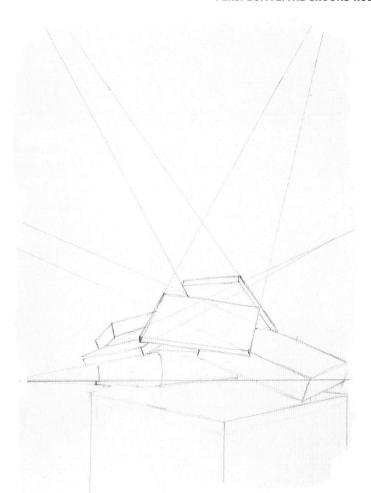

Vanishing points do not always meet at eye level. Inclined planes, like those you would see in an untidy heap of books or boxes, will all have varying vanishing points. If you follow the converging horizontals and verticals, they meet at places both above and below the true horizon.

Understanding and using color

S ir Isaac Newton (1643–1727) first put forward the theory that the spectrum was composed of seven colors—red, orange, yellow, green, blue, indigo, and violet—and in 1704 he presented these colors in the form of a circle that has become known as the color wheel. This famous wheel is now the standard method of arranging colors.

One of the most difficult areas of painting is the accurate—or at least visually pleasing—representation of color. The primary colors in painting—red, blue, and yellow—can be mixed to make any other color, apart from black and white. However, because the mixes are so subtle and the colors are easily muddied, mastering color mixing can be challenging.

There are, of course, some basic rules that can help you create good color mixes. Understanding what happens when two colors blend—which is the stronger and which the weaker—how to lighten colors, how to avoid the "unnatural" qualities of so many ready-mixed tube colors, and how to add just the right balance of one hue to another are all skills that are developed with practice and repetition.

When painting, examine your likes and dislikes for color, and approach mixing with an open mind. Understanding basic color relationships—such as contrasting and complementary colors, families of colors, and color mixing—is a starting point for all painting. Then learning about glazes and experimenting with the specific color mixes demonstrated in this chapter will help you establish a comfortable relationship with color and color mixing.

Secondary colors

Secondary colors are those that are created by mixing two primaries. But there are also both "warm" and "cool" versions of each primary. Warm primaries tend to be on the red side and cools tend toward blue. For example, crimson is a cool red and cadmium red is warm. To mix the cleanest secondaries, use two primaries that are close

The color wheel shows clearly how the primary colors mix to create the secondary colors.

This orange is the product of a mixture of cadmium yellow and cadmium red, producing a clean, clear secondary color.

1284

to each other on the wheel and so close in "temperature." To create a clear orange, use a red and a yellow that are both on the orange side, such as cadmium red and cadmium yellow. To mix a clean green, use a green like phthalocyanine blue or manganese blue, and mix it with cadmium yellow or cadmium yellow light.

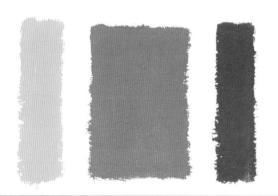

To make this strong, opaque green, manganese blue has been mixed with warm cadmium yellow. If a cool lemon yellow had been used instead, the resulting green would have been much sharper.

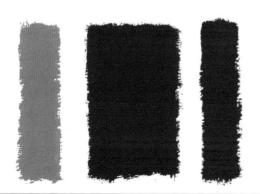

Violets can quickly become muddy purples. To make as clear a violet as possible, mix a light cobalt blue with a permanent rose.

Secondary colors are mixtures of two primaries; tertiaries are made from all three. If you mix two secondary colors together, you will get a tertiary, as all three primaries are in the mix. Tertiaries are subdued, subtle, and sometimes muddy. If you mix two primaries that are leaning in opposite directions, you may get a muddy effect. For example, mixing a cool phthalocyanine blue with a warm cadmium red will produce a brownish purple. Orange and green can produce an olive green, and orange and purple make a rich burnt orange.

Using mixtures of secondaries is a way of making rich dark colors without using black, which can deaden color. Violet and green make the most somber of tertiaries. In this example, a light green and warm violet have been gradually mixed. Notice that the stripes have become quite dark in the center.

TERTIARY COLORS

Here cadmium orange and violet make warm burnt oranges. If the violet were bluer, then the result would have been darker and earthier.

This illustration shows the progression from one secondary color (orange), toward another (green). On the way, it makes rich olives. These greens might be very useful when painting the foliage of some trees—the new shoots of the oak in spring are orangey green, as are many trees when they begin to change color in the fall.

Complementary colors

Complementary colors are those opposite each other on the color wheel. These contrasts are juxtapositions of a primary color, such as red, with a secondary color such as green. Green is "complementary" to red because green is made from the remaining two primary colors—blue and yellow. Therefore orange is complementary to blue and violet complementary to yellow. The so-called primary colors you buy are not absolutely primary—they will lean toward one of the other primaries. For instance, cadmium red is slightly orange, closer to yellow (warm); crimson tends toward violet, closer to blue (cool). So the true complement of cadmium red must be a green containing more blue; the green complementary to crimson must contain more yellow.

This grouping of colors illustrates that after you have mixed blue and yellow together to make green, red is the remaining primary color. Red is therefore green's complement. Here, cadmium yellow has been mixed with manganese blue to make the green, and the complement of this green is cadmium red.

COMPLEMENTARY COLORS | 3 4 4 4

Yellow is violet's complementary color. So, to achieve the most appropriate violet, light blue-violet and permanent rose—two colors that tend toward violet-were mixed. A more orange red or greenish blue would produce a muddy purple that would not be such an effective complement. Notice that there is a greater tonal difference between yellow and violet than there is between the other complementary pairs.

Blue is orange's complementary color. Here, cadmium yellow and cadmium red—two warm hues—have been mixed to create the orange.

Blending colors on the canvas

Colors can be mixed on the mixing palette or directly on your painting. It is best to add strong pigments—such as ultramarine—gradually into weaker ones—such as lemon yellow—so that you don't overwhelm one with the other. Try out different methods of working one color into another, and you will gradually come to understand the intricacies of mixing. Experiment with the different methods shown below as a start.

Acrylics dry rapidly so you must quickly blend colors together on your painting. In this example, manganese blue and orange were brushed into each other, producing a greenish gray where they meet. When mixed, complementary colors tend to cancel each other out and create neutral grays. However, the less precise the complementaries, the browner the result will be, rather than gray.

BLENDING COLORS ON THE CANVAS

artist's note

The kind of blend you use depends on what you are painting and how you paint. For instance, if your subjectis an old stone wall, avoid thorough mixing in favor of inefficiently mixed combinations of colors to capture the irregularity of the stone. If you are painting from one color into another in a graduated way, your blending will have to be done carefully using a soft brush to smooth out abrupt changes.

With the more transparent qualities of pigments, you can create blends by laying one color over another once the undercolor has dried. In this illustration, a transparent orange has been used over an opaque manganese blue. Where the blue is thinner, the orange is more visible. In this type of blend, the colors remain apart, adding a sense of depth to the layers.

The additive method of color mixing is shown here. Strokes of pure color are laid against one another, increasing the quantity of one against another so that the intensity of either individual color is lost in the center.

Glazes—and how they affect color

When artists began using oil in the Renaissance, a great technical advantage was that pigments could be suspended in a medium that allowed the painter to apply one layer on top of another. By alternately layering transparent pigments with richer colors, deep glazes could be achieved, giving greater overall depth. Acrylic offers the same advantage with the added benefits that it needs no additive and it dries quickly.

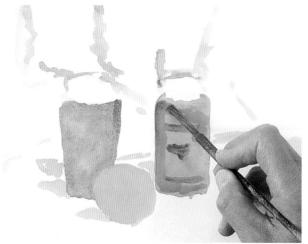

Sketch out a composition that offers a variety of colors—light to dark—with a neutral tonal background and some areas of white. This will best highlight how a glaze can work. Here, the jam jar on the left has an outline of permanent magenta with block colors of an opaque orange. The apple is cadmium yellow, and the right hand jar is transparent phthalocyanine green.

GLAZES—AND HOW THEY AFFECT COLOR

, 45A ...

There are many ways to exploit glazing. Glazing in many thin layers is ideally suited to subjects like seascapes, skies, and still lifes with glass or ceramic objects. A transparent glaze over the colored ground will help create the illusion of depth in the painting. Glazing over pale colors or an opaque white will sharpen the quality of the colors. The darker the original color, however, the less effect a glaze will have.

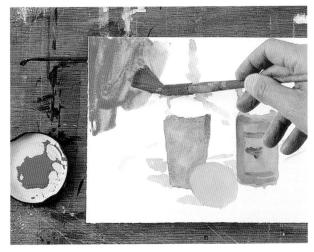

Dilute the orange to a thin consistency, and brush on the transparent color. The bright white of the paper will disappear, but it should still "glow" through the transparent glaze, allowing us to see its color.

UNDERSTANDING AND USING COLOR

The depth that a transparent glaze can give a painting is clearly illustrated here. Notice that the orange jam jar sinks into the glaze as if in a colored fog while the green jar becomes more subdued.

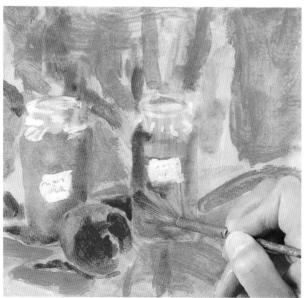

Paint in the tops of the jam jars with titanium white. Then apply permanent rose to make the apple more solid. Brush on some more layers of the transparent orange as well as the transparent permanent rose to give the folds in the cloth greater depth.

GLAZES—AND HOW THEY AFFECT COLOR

For the final touches, paint the jam jar labels with titanium white and add some further highlights to the plastic wrap tops. Notice that the transparency of the glaze sets off these points of opaque white. In a more developed painting, specific areas could be glazed with other transparent colors. Painting opaque white and then glazing over again with another transparent color is a way of adding colored highlights to the painting.

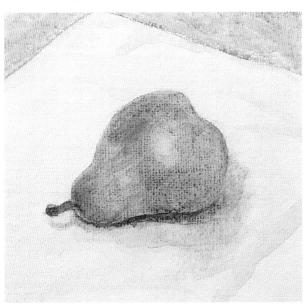

Pear with glazes This study of a pear was created with a flat ground color of yellow with a small area of titanium white. The shadows and tones were built up using only glazes. Layers of ultramarine were painted over the yellow to gradually build up the hints of green all over the pear, while the russet tones of the underside were created with a glaze of naphthol crimson. The veils of color give depth and gloss to the surface of the fruit.

Capturing soft, delicate pinks

Pinks can prove difficult to mix—you will not be able to mix the pinks of flowers like geraniums and carnations from the standard primary reds. The cadmium reds produce pinks that vary from pinky orange to strawberry ice-cream pink. They are too vivid and strong for the soft

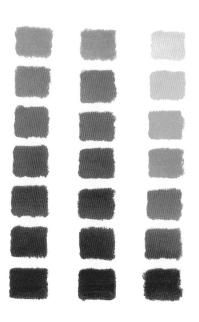

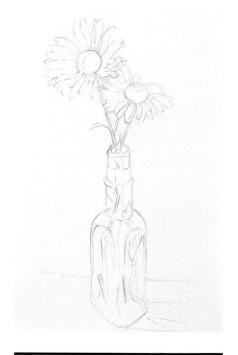

The color chart above illustrates the range of pinks obtainable when you mix degrees of titanium white with permanent rose (left column), quinacridone red (center column), and cadmium deep red (right column). Make your own pink color charts, and refer to them when you paint pink flowers.

Sketch the composition lightly in pencil, accurately capturing the delicate petals. Do not draw too heavily or erase too roughly if you make a mistake; the marks will show through the thin, pale, and subtle acrylic colors. Paint in the stems, leaves, and bottle so that you can match the tone of your pinks to them.

CAPTURING SOFT, DELICATE PINKS

pinks of flower petals. More delicate and subtle pinks are best mixed from transparent colors like permanent rose, quinacridone red, and quinacridone violet. These allow you to maintain the subtlety and delicacy of the tones.

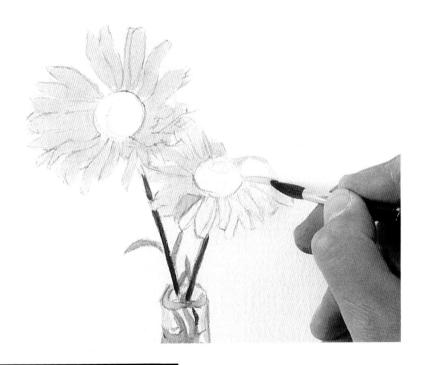

Underpaint the petals individually using a diluted permanent rose. Be patient when painting flowers. If you rush to fill in the petals, they will merge together, and you will lose the shape of the flowers.

UNDERSTANDING AND USING COLOR

artist's note

Adding white might seem the obvious way to make your color lighter, but this can result in dullness, especially if your color is opaque. Another way to lighten color and retain the purity of the pigment is to use a transparent color and paint a thin glaze of it over a brilliant white underpainting.

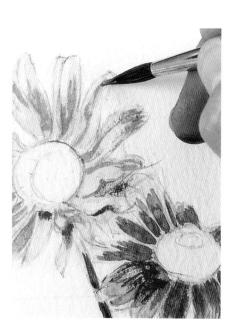

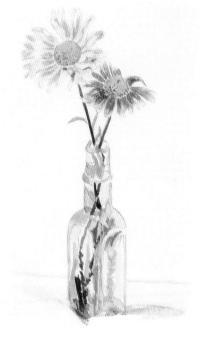

Paint over the petals with a more intense pink of the same permanent rose but with less water in the mixture. To retain the light areas of the petals, do not paint over the paler underpainting.

Paint the yellow centers of the flowers last. Here, a lightly painted cadmium yellow base color was speckled with a mixture of Hooker's green and Payne's gray.

Demonstration: Flowering artichokes by the pool

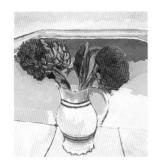

If you love color, then flowers are the perfect subject. They also present some interesting challenges to a painter's ability to identify and find those colors in the paintbox. The pink, cerise, violet, and magenta hues and their tints are among the more difficult colors to create. To capture

the freshness of flowers, try to mix as few colors as possible to create the colors you need. The more colors you add to a mixture, the duller the result will be.

Begin with a simple brush line drawing in quinacridone blueviolet, thinned with water until the consistency allows a flowing line. Keep the drawing simple, ignoring the texture and detail within the artichoke flower head at this stage.

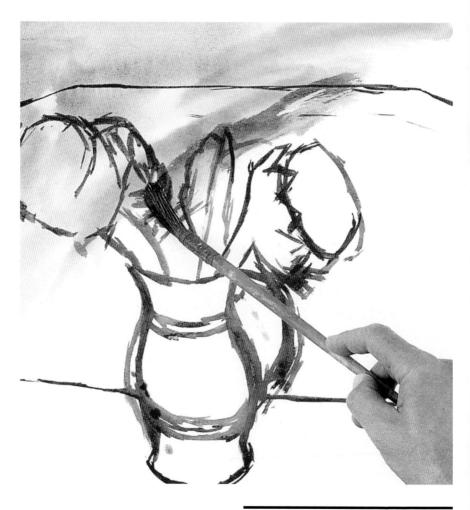

Apply a thin glaze of the transparent permanent rose. This will immediately provide a base to gauge the relationship among the pinks as well as the surrounding colors you will add later.

DEMONSTRATION: FLOWERING ARTICHOKES BY THE POOL

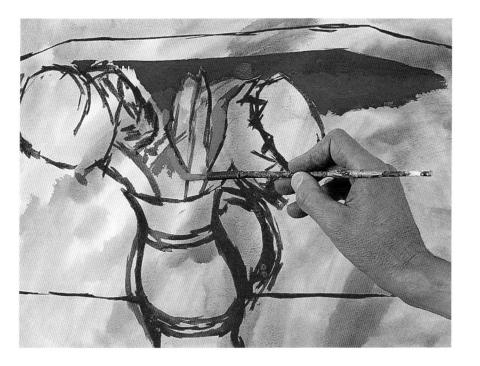

Manganese blue—actually a mixture of phthalocyanine blue and green and titanium white—is perfect for the water of the swimming pool in the background. Use this color to paint into the contours of the artichoke heads and to separate them from the background color.

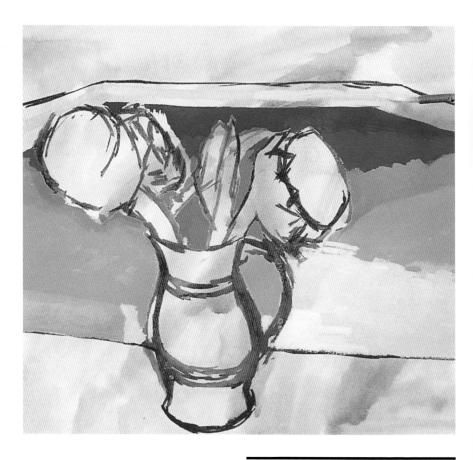

Block in the swimming pool with varying tones of the greenish blues from step three. Paint the bottom right-hand corner in a mixture of light blue-violet and titanium white to capture the reflective light of the pool. These blocks of blue will form the perfect backdrop for the vibrant colors of the flowers.

DEMONSTRATION: FLOWERING ARTICHOKES BY THE POOL

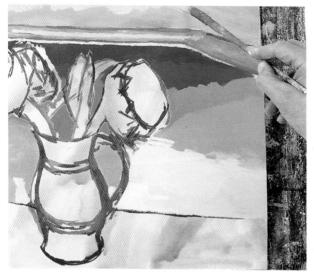

For the sun-drenched garden behind the pool, use a mixture of yellow ocher and titanium white. As you paint, leave out any distracting detail, and let it become a "hot" border around the cool interior of the pool.

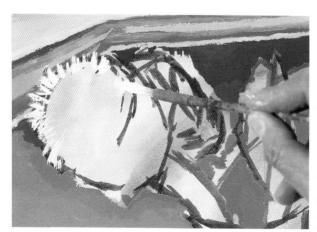

In preparation for the later color glaze, paint a generous coat of titanium white onto the artichoke heads. Use a long-haired fresco brush to create short, choppy marks for the fine, compact fibers of the flowers.

UNDERSTANDING AND USING COLOR

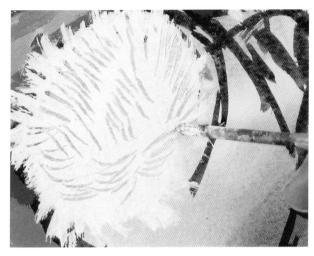

With the handle of the brush, scratch through the thick white paint to reveal the pale permanent rose underneath. This adds texture and also contributes to the complexity of the pinks.

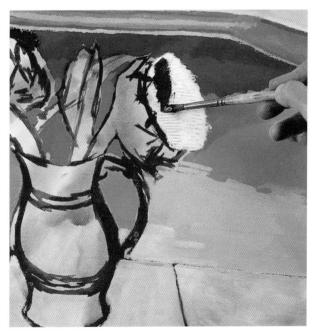

Quinacridone magenta is an intense, transparent red-violet, close to the color that you need for the artichoke flowers. Dilute it so that the white underpainting gives it the brilliance you want; then paint over each flower.

DEMONSTRATION: FLOWERING ARTICHOKES BY THE POOL

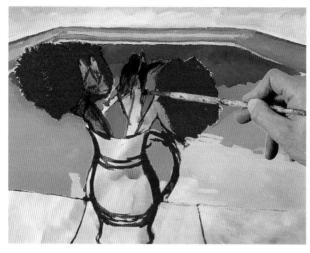

Paint in the fleshy leaves and stems of the artichokes with a variety of greens made from Hooker's green, Hooker's green deep hue, and olive green. In places where there is reflected light, apply the color thinly so that it retains more brilliance. Where the shadows fall, apply it more solidly.

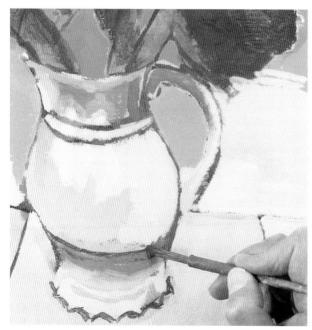

Before you begin painting the jug, take note of where the light and shadows fall. As you paint the belly of the jug with titanium white, utilize the permanent rose underpainting; allow the white to soften into the pink for the faint shadowy area. Then paint the convex curves with varying tints of quinacridone gold and the stripes with cobalt blue.

UNDERSTANDING AND USING COLOR

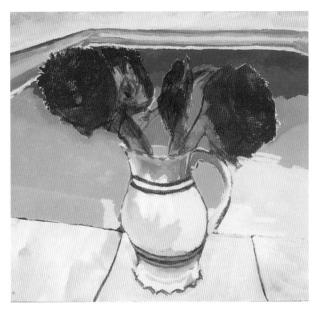

At this stage, the painting is not far from completion. The overall color composition is established; it now requires refinements and detailing in the flowers and the tiles at the pool edge.

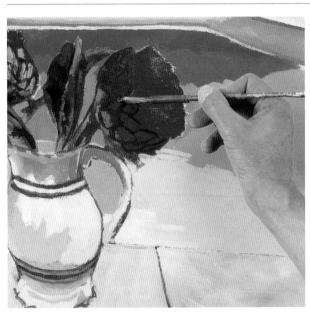

As if in a cup, the fibers of the artichoke emerge from a surrounding of diamondshaped, overlapping leaves. As you paint the leaves with Hooker's green, let some of the quinacridone magenta show through to give them depth and body.

DEMONSTRATION: FLOWERING ARTICHOKES BY THE POOL

There are some darker patches in the centers of the flowers. Paint these gradually and carefully so that the color does not become too heavy and solid. Use a mixture of two transparent colors—quinacridone magenta and Hooker's green—and apply it thinly. Before it dries, scratch the paint with the handle of your brush to reveal the lighter color beneath, adding texture to the inside of the flower head.

UNDERSTANDING AND USING COLOR

The detail added to the flowers has flowers in the foreground.

given them a threedimensional quality, and they now stand out strongly against the blue background of the pool. The eye is drawn to the intense colors of the

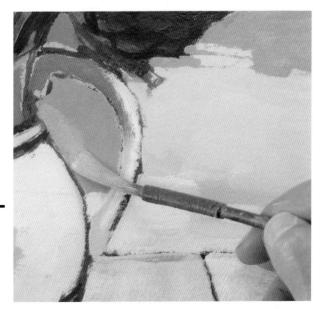

Using a mix of manganese blue, lightened slightly with titanium white, darken the pool behind the jug to give it some definition.

DEMONSTRATION: FLOWERING ARTICHOKES BY THE POOL

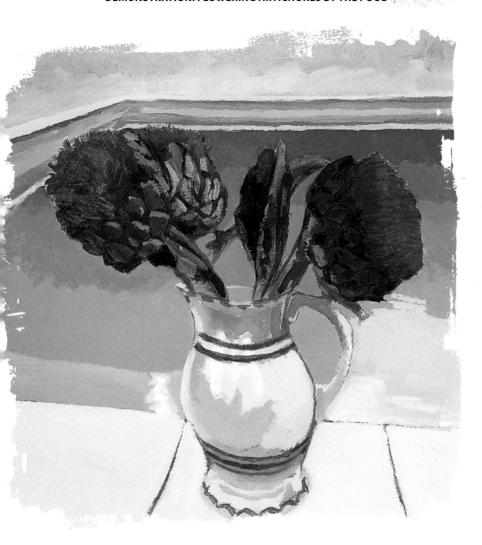

1 6 For a final touch, paint the tiles in the immediate foreground with a mixture of parchment and titanium white. This will keep the deep and powerful color of the main elements confined to the central horizontal plane.

uriously, the French and English terms for this genre of painting seem contradictory. The French term, nature morte, probably dates to the period when still life paintings were largely depictions of the animals and birds caught at the hunt. The English term, still life, suggests living things in a state of rest. But however it is interpreted, a still life is usually domestic and often quite small in scale. And it offers artists an opportunity to display their skill in rendering the contrasting surfaces of objects.

Jean-Siméon Chardin (1699–1779) loved to set off the gleam of pewter against the bloom of a peach. The painters of seventeenth-century Holland composed highly contrived arrangements with important symbolism. *Memento mori* or *vanitas* paintings were allegories, created to remind the viewer of the transitory nature of life; the objects depicted would include a skull, an hourglass, and a fruit with a worm in it.

Many modern artists have found that still life painting continues to fascinate, from the strangeness in Giorgio de Chirico's juxtapositions of classical busts with a pair of rubber gloves to the aggression and anxiety in Picasso's wartime paintings of food.

What all the great still life painters have in common is a feel for objects, as well as the ability to make the everyday and ordinary into something that resonates.

Still life painting probably poses the most problems for artists, simply because the range of objects is almost unlimited. From reflective surfaces to folds in cloth; from the bloom on fruit to the petals on flowers; and from every texture, shape, and color combination in between, all are the lot of the still life painter. As with all forms of painting, the real mastery in rendering a still life lies in accurately observing the objects and representing them in a way that the viewer will find both interesting and compelling.

Painting still life for the first time

When approaching a still life painting, choose objects that interest you. Start with simple things like fruit and flowers or everyday domestic objects. The next step is to arrange your objects. If this is your first still life, keep the setup simple.

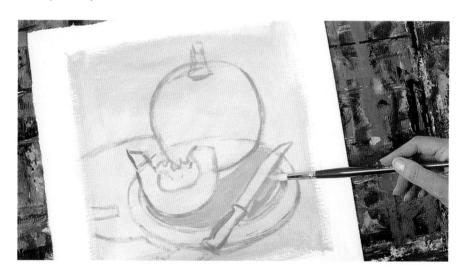

Begin by arranging your objects to create visual interest. Despite its simplicity, the varied shapes of the pumpkin, breadboard, knife, and pumpkin slice create a compelling composition. Next, apply an underpainting with a mix of raw sienna and cobalt blue. Then make a quick brush drawing with a mix of raw sienna and titanium white, keeping the objects in proportion to the size of the paper. Use the same color mix for the board.

PAINTING STILL LIFE FOR THE FIRST TIME

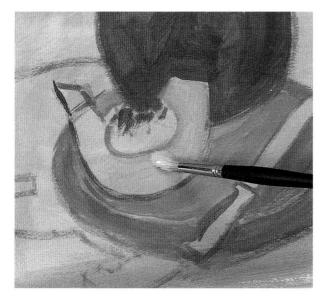

Paint in the base colors for the objects in the composition. Bear in mind that the painting must work as a whole, as well as represent each element. Use brush strokes to help capture the textures, such as the slightly dusty, dull surface of the pumpkin offset against the smooth, shiny metal of the knife. Generously paint the pumpkin slice in yellow. Because this is a semitransparent color, the pale gray underpainting will still illuminate the yellow.

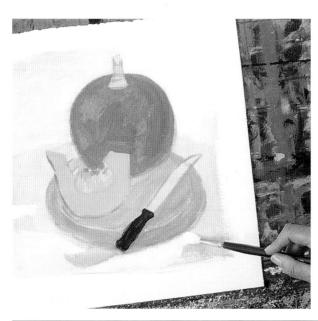

The darkest object in this composition is the handle of the knife. This will be a visually demanding element of the finished painting, so it has been angled in the composition to draw the eye up into the center of the painting. Paint the handle with a mixture of red oxide and ultramarine. Then add the highlights with titanium white, taking full advantage of the underpainting; use it to create shadows, again increasing the sense of three dimensions.

RENDERING STILL LIFE

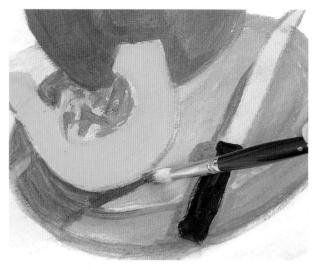

Paint the main blocks of color, such as the yellow and ultramarine mix on the interior of the slice. Next, add the major shadows, such as the cadmium orange and ultramarine mix on the skin of the slice and the shadows on the breadboard, taking care to keep them consistent with the light source.

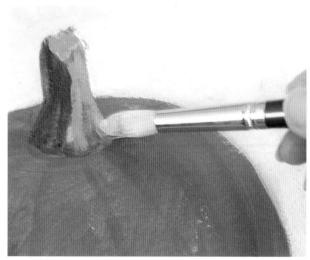

Next, paint the details of slight color changes on the stem with the same mix of raw sienna, cadmium orange, and ultramarine used for the shadows on the board. As you come to the shadow side of the stem, darken it with more ultramarine.

PAINTING STILL LIFE FOR THE FIRST TIME

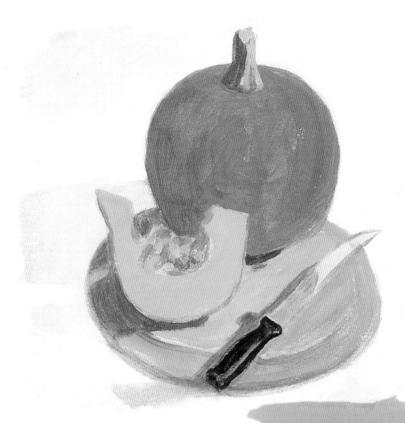

Now you can add the final details to the painting. For the dark edge of the knife blade, gently brush on a touch of cobalt blue, using the underpainting as the main color. Then lightly brush in the lines of the pumpkin using a mix of cadmium orange and ultramarine.

artist's note

Arrange a still life to include a variety of textures and forms. Couple curves with flat surfaces, reflective surfaces with matte, and large objects with small to practice drawing objects in relation to one another. Let some of the objects overlap to give a sense of cohesion. Look for strong lines and use them to dramatic effect.

Painting three-dimensional objects

It is not difficult to paint convincing three-dimensional objects, but it is vital to observe carefully how the light is striking the form. We recognize three dimensions by the way the light and shadow play on the form: the lightest areas are nearest the light source, and the shadows are where the curves or edges shelter the object from the light.

By concentrating on the effect that light has on the colors and textures of the object, it is relatively simple to turn a circle into a sphere and that sphere into an orange, as demonstrated here.

To create a three-dimensional picture of an orange, paint a basic outline in bluc. Block in the body with cadmium orange. Apply the paint more thinly to the top in order to capture the way that light catches the little indentation from the fruit's stem.

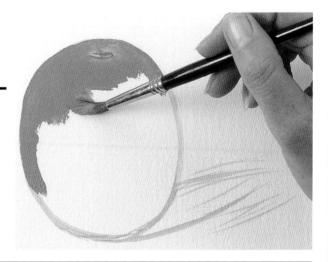

PAINTING THREE-DIMENSIONAL OBJECTS

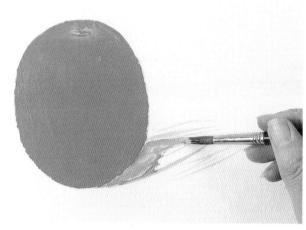

Once the orange is completely covered, you can begin to paint the cast shadow detail with a mixture of blue, titanium white, and a tiny amount of cadmium orange. Shadows are not solid areas of one color. and the shadow cast by this orange is picking up reflected light. This makes the center of the shadow lighter where it is faintly illuminated by soft light bouncing off the surface of the orange.

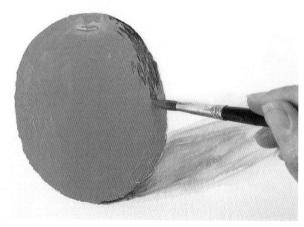

There is no need for a great variety of color to capture the shadow on the dark side of the orange. Use the same mixture as you did for the shadow before with a little more blue. Apply the paint in small dashes to duplicate the surface texture of the skin.

RENDERING STILL LIFE

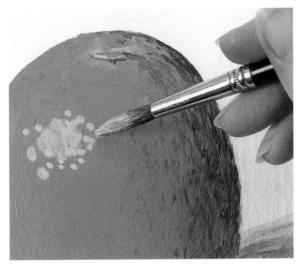

With a mixture of titanium white and cadmium orange, use a stippling technique to add highlights that capture the texture of the orange skin. Highlights are easy to overdo, and a common mistake is to make them too white: then they do not relate properly to the lighting conditions in the rest of the picture. When painting highlights, compare them with other light areas, or even compare them to something white so that you can be sure that you are not making them too stark.

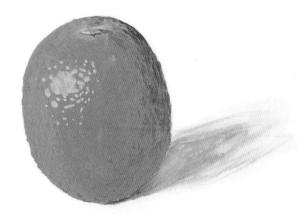

By faithfully duplicating nuances in light and shade, this painting of an orange has progressed from being a flat, orange-colored circle to a textured, properly spherical representation.

PAINTING THREE-DIMENSIONAL OBJECTS

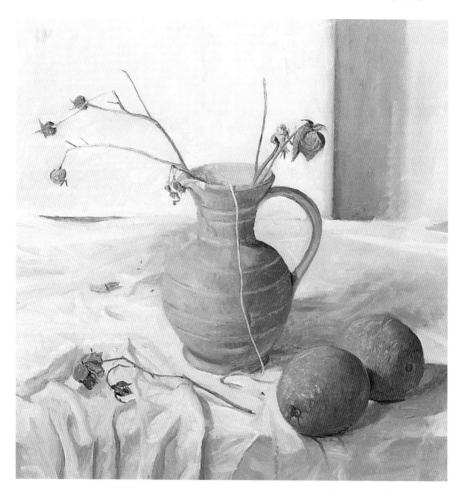

Here you can see that the light source is in the left of the painting. The darkest areas of shadow are on the right-hand sides of the objects, but the tablecloth throws back a little light onto the lower parts of the oranges' shadows. The horizontal curves of the jug add to the three-dimensional look, but the gradual deepening of the browns around its curves is what really makes it stand out against the background.

Painting realistic drapery

Drapery is a common element in still lifes, and one that can greatly enhance a composition. It's a good idea to practice painting cloth separately until you become comfortable incorporating it into your work. Start by draping the cloth over a chair or gathering it into distinct folds on a table; then set up a light source that creates strong highlights and shadows.

Pale fabrics

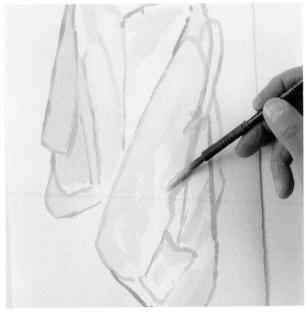

First draw a basic outline of the general contours of the cloth: the edges, the seams (if applicable), the main areas of shadow, and the lines of the major folds or creases.

PAINTING REALISTIC DRAPERY

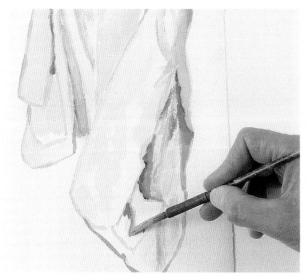

Next, paint the lightest values of the cloth, with a mix of cream and white, varying the tone where needed. Then, establish the darker tones, using Payne's gray mixed with a little white. Let the shadows gently fade into the white and cream for a soft transition.

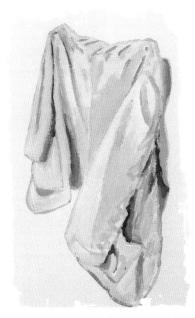

Once the darker values are in place. work more of the cream and white mix into the painting, softening the shadows and folds.

Shiny fabrics

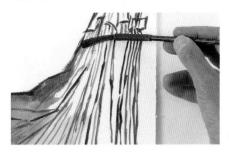

Using a transparent green, paint the whole of the silk garment with a thin wash so that the creases are still visible.

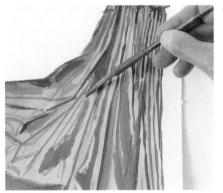

Silk easily picks up the differences between natural daylight and artificial light. Use a mixture of Hooker's green and light green permanent to paint the warm light from the house light. Then with a mix of transparent green, bright aqua green, and cobalt turquoise apply the areas of cold daylight.

The pink in the garment also responds differently to the two light sources. Apply permanent magenta for the cooler daylight pink and use perinone orange for the artificially lit hues. Paint the darkest shadows with Payne's gray to further define the silk folds.

PAINTING REALISTIC DRAPERY

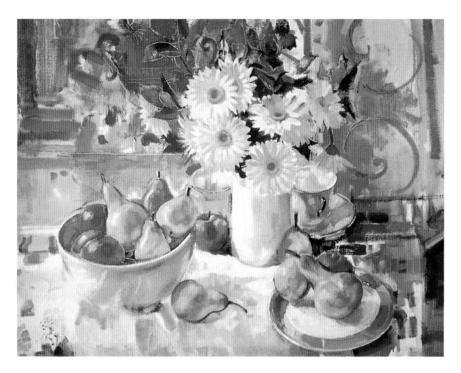

The white cloth in this still life painting is almost as visually important as the objects set on it. There are no hard lines painted in the fabric, but the changing colors in the shadows clearly show where it drapes over the edge of the table. The hard edges at the sides of the cloth give it greater impact in the center of the painting. The area of pale light draws the eye up and through the composition, from the cloth to the white flowers. Even though the colors of this fabric are muted and subtle, they pick up the purples and oranges behind the flowers and create an area of calm in an otherwise vibrant composition.

Painting glass

Clear glass does not completely reflect its surroundings the way metal does. Objects can be seen through it as well, and varying thicknesses of glass can create distorting effects that can make it seem difficult to portray the substance of the object without losing its

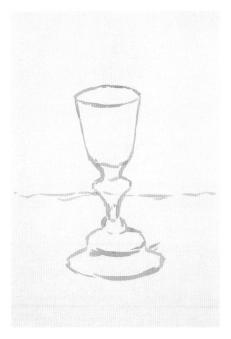

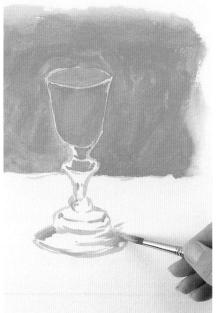

Start with an empty glass on a plain background. Lightly sketch the outline with Payne's gray and orange. This is a mid-tone gray, halfway between a cool and warm color, so it is relatively neutral.

Next, paint the background—in this case, a light blue—leaving an edge of white around the outline of the glass.

Add reflections from the background to the foot of the glass.

transparency. Yet it is this apparent lack of substance that makes glass so intriguing to paint. The main objective in painting glass is to let the colors of elements behind it, and its highlights and reflections, create its form. Once again, it is the play of light and dark that creates the object's form.

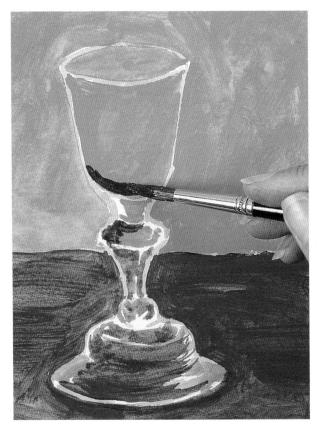

Fill in the foreground with a strong transparent hue, such as the quinacridone red used here. Continue the color over the glass where it can be seen through the glass foot. As the color is transparent, applying it to the base of the bowl darkens the existing blue, creating a sense of weight and density.

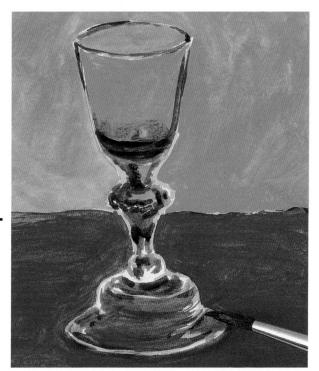

Where the glass appears thicker, paint pockets of darker color with a denser mixture of the same Payne's gray and orange you used for the outline. Now the glass is beginning to take form, with a balance of transparency and substance.

Now add some highlights to the back of the inner bowl of the glass. This will increase the three-dimensional effect. Use strokes that follow the texture of the glass—straight vertical lines for smooth glass or short horizontal lines for the slight texture shown here. Build up the highlights gradually; you can always add more later.

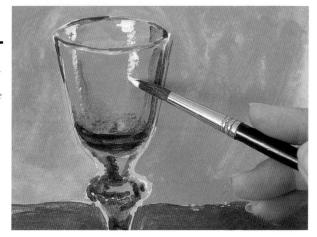

artist's note

Colored glass or glass containing liquids will have subtle color changes and additional reflections in the liquid. Just look carefully and paint exactly what you see.

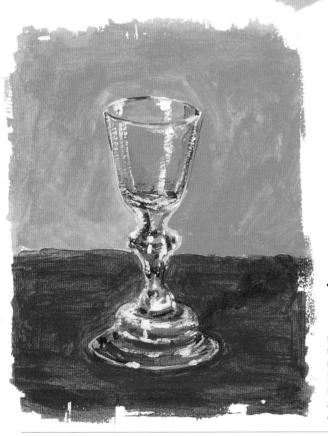

Finally, paint the subtle shadow the glass casts on the table surface. Do not overwork the study or it may become too heavy. It is better to leave it slightly unfinished than to make it too solid and lose the transparent quality of glass.

Painting lifelike flowers

Capturing the freshness and purity of a flower's color, the delicacy of the shadows on the petals, and the intricate curves and curls of blossoms are challenging, but very rewarding, aims for the painter.

If you are completely new to floral painting, start with only one or two flowers, and sit quite close to them so that you can see every detail. Then sketch the flowers with a brush and thinned paint. You may feel more comfortable drawing with a pencil, but the danger is that you may become too fussy and bogged down in detail. If you draw with a brush and diluted paint, you will have to simplify the shapes and consider color from the outset.

It is important to keep your colors as fresh as possible when painting flowers. Here, sketch the outline with yellow. Next, delineate the darkest parts of the petal folds. Here the dark pinks are painted in quinacridone red.

PAINTING LIFELIKE FLOWERS

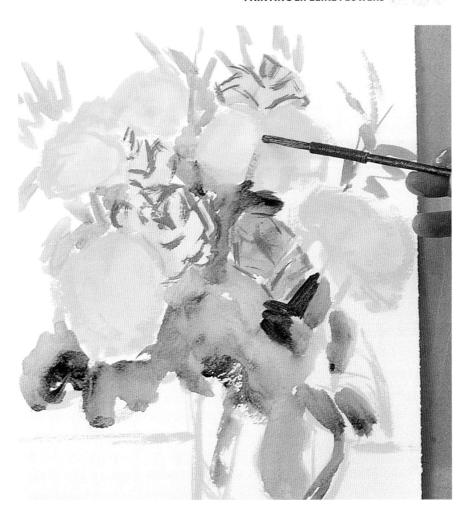

This is where the transparency of some colors is extremely useful. Using diluted yellow and quinacridone red, glaze over the yellow and red drawing, allowing the original underpainting to act as the deepest part of the flowers. Apply Hooker's green to the outer contours of some of the flowers to create a base for foliage.

RENDERING STILL LIFE

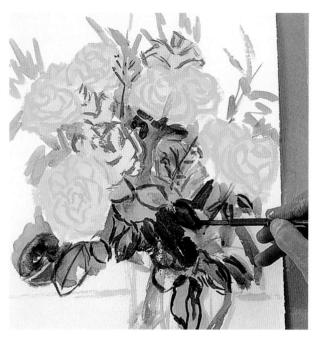

Using a more concentrated mix of Hooker's green, further develop the leaves. This will also help to define the outer contours of the blossoms.

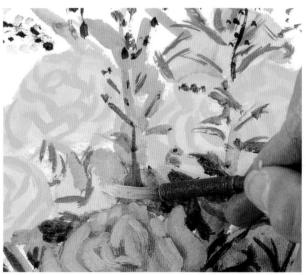

Next, paint the petals in stronger tones. Here the pink roses are blocked in with an opaque mix of quinacridone red and titanium white. It is important when mixing color for flowers that you do not blend too many colors together; the more you put into a mixture, the duller it will become. It is better to have a clean, fresh color that is not quite accurate than to struggle until it becomes so muddy you have to start again.

PAINTING LIFELIKE FLOWERS

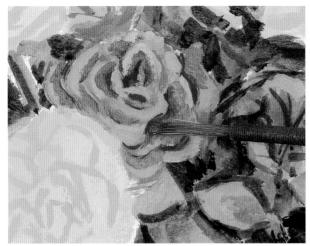

To create the deeper undersides of the petals, work from the sharp edge of the petal to where it softly merges with the lighter body of the petal. Here a blend of quinacridone red with a tiny touch of quinacridone burnt orange creates the deeper pinks.

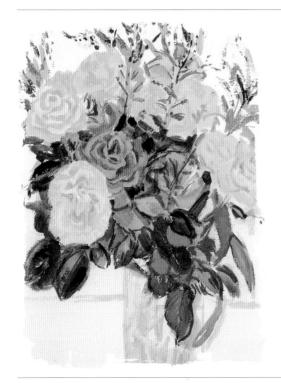

For the final touches, add highlights where needed using titanium white and yellow. This gives the yellow flowers a little more depth.

Painting reflections in metal

Metallic objects are fascinating to paint. Metal reflects the colors and shapes of surrounding elements, but it does not pick up perfect mirror images. Instead, the images are distorted by the shape of the metal object itself. Although reflections are exciting to duplicate—creating

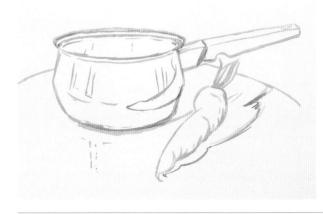

In your basic sketches, include the outlines of the reflections in the metal pan. Although you don't want them to overpower everything else, the reflections will be an integral part of the painting and must be considered from the outset as part of the composition.

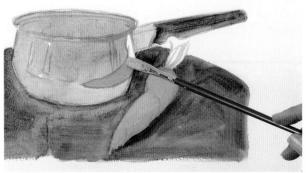

As you block in the colors, include the carrot's reflection in the saucepan. Notice that the shape follows the contour of the pan and is reflected on the underside of the pan lip as well. For the table, lighten the color where light from the pan is being reflected.

PAINTING REFLECTIONS IN METAL

whole worlds in miniature—it's easy to become overly involved with details and make the reflections more important than anything else in the painting. As you paint reflections, be aware of their relationship with the rest of the painting in terms of detail, color, and shape.

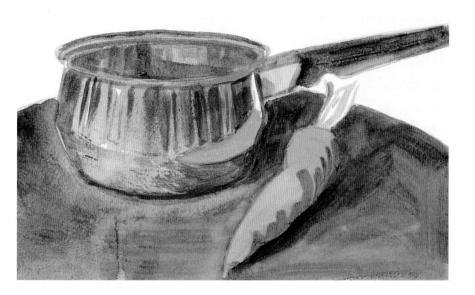

Use Payne's gray for the metal pan, varying the edges of the dark streaks; in some places, the dark gray is in considerable contrast with the tone next to it, while in other places it is quite subtle. Note, too, that the grays contrast with the pale orange streaks in the lip of the pan.

RENDERING STILL LIFE

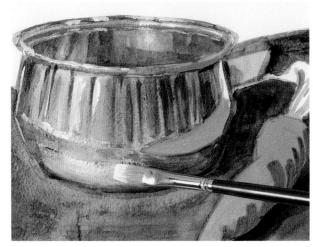

Titanium white is ideal for highlights on the side of the saucepan, as it allows the gray to come through weakly. Apply the highlights with the edge of a flat hog brush to make narrow shapes; use the broad end for much thicker marks.

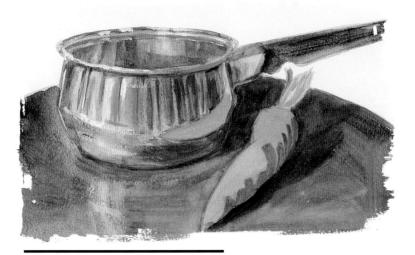

The completed study shows an integrated image. The reflections of the carrot and the umber of the tabletop do not call undue attention to themselves but remain in balance with the whole. Note the subtle reflection of the pan in the surface of the table.

PAINTING REFLECTIONS IN METAL

artist's note

To a large degree, the secret to painting reflective objects is in correctly observing the tonal relationship of the parts, ensuring that the differences between light, middle, and dark tones are understood and painted accurately.

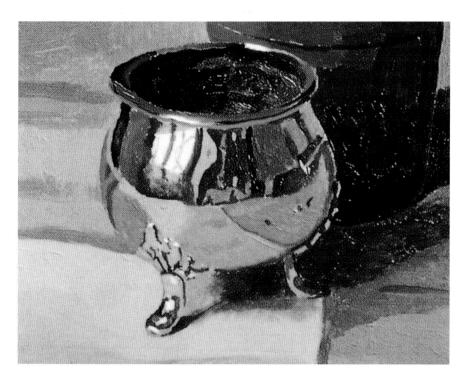

The world in miniature

In this example, the detail of the reflection in this copper bowl is stunning. If you look carefully, you can see the artist and the entire room behind him.

andscapes have been particularly popular subjects for artists since the end of the eighteenth century. Landscape painting in watercolor became an accomplishment enjoyed by middle-class women who traveled to picturesque places. Drawing and painting in watercolor were also part of the training of British naval officers. It was a very good exercise in observation, and—before the invention of the camera—it was the only way to provide visual information about newly discovered parts of the world.

In the salons and academies, landscape painting gradually emerged as an art form in its own right, rather than just as a background for battles and portraits of the gentry. The landscape, as painted by masters such as John Constable (1776–1837) and J.M.W. Turner (1775–1851), became an ambitious subject for an artist, recording the beauties of the local countryside, or romantic vistas of mountains and stormy seas.

The French Impressionists probably popularized landscape painting more than any other group of artists or movement. Enabled by the newly invented screw-capped metal tube (in 1841, a New Hampshire artist, John Goffe Rand, extruded the first tube of tin to hold artists' oil colors), painting outdoors with oils became much more practical, and the Impressionists set a new standard in freshness and immediacy in their landscape paintings.

When painting outdoors, do not work longer than 2½ hours on one painting; by that time, the light will have changed enough to mean either starting over or coming back at the same time another day. If you are close to the tropics, the light tends to remain stable for longer, so you might get away with another hour, but obviously the direction of shadows will have changed dramatically. It is good practice to fix the shadow positions about halfway through the painting; by then you should be familiar enough with the color to remember any changes.

Uniting the foreground, middle ground, and background

Creating a convincing continuity of depth in space—especially if there are few obvious divisions like rows of trees or hills—is an interesting problem. There has to be a natural and gradual change from the objects that are nearest and clearest to the elements in the far distance, where things tend to blur and merge together. The demonstration below shows how to create a seamless change in focus from the near to the far.

Because the horizon is very high, the composition allows only a thin strip of sky, with a large area of land in the foreground to create a sense of distance. Here we have a large distance between the foreground and the background. Begin by underpainting the field in red oxide with a touch of ultramarine. then fill the sky with ultramarine and titanium white, and block in the broad line of distant trees in thinned ultramarine.

UNITING THE FOREGROUND, MIDDLE GROUND, AND BACKGROUND

The focus of the painting is the distant building and tree line. Paint the trees with a relatively thin mixture of Hooker's green, yellow ocher, and titanium white, so they are not too solid against the sky. Leave a small amount of the reddish ground showing through the trees in order to help unite the middle and back grounds.

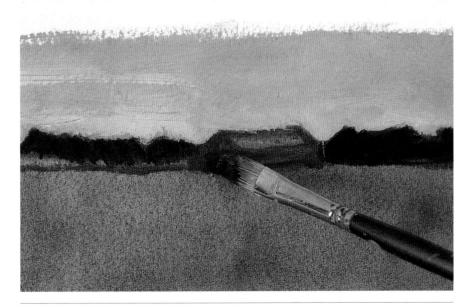

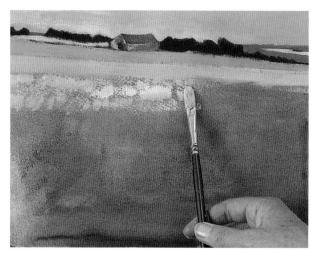

To link the background to the foreground, paint the subtle band of the wheat with varying mixtures of yellow ocher, red oxide, and titanium white, using gradually lighter mixes as you move toward the middle ground. Dab on the paint in irregular horizontal strokes to indicate masses of corn.

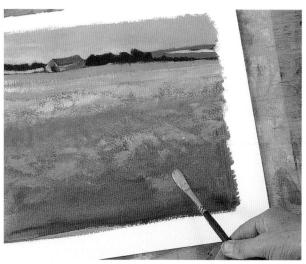

Now we want to add some of the rich, golden color to the foreground. Using the same colors as the rest of the field but with more pure yellow ocher and a little Hooker's green, add more strokes for corn, gradually making the transition from broad shapes to the more specific shapes of individual stalks and ears.

UNITING THE FOREGROUND, MIDDLE GROUND, AND BACKGROUND

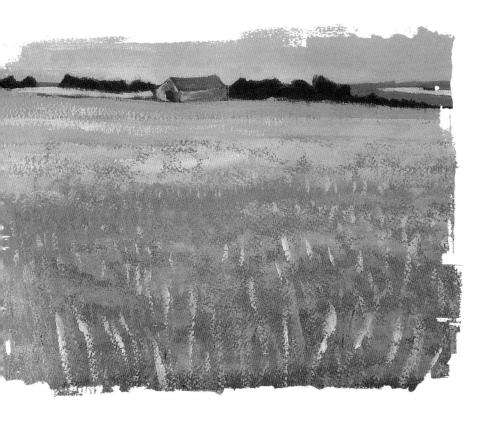

Make a few vertical strokes of yellow ocher and titanium white to give an impression of standing wheat. Make the strokes smaller and finer as they recede until they melt into the horizontals of the middle ground. Let more of the red oxide underpainting show through in the foreground; this extra warmth will help the relatively cooler middle and background recede into the distance, and also suggests the red of the soil.

Showing extreme distance

To create a complete illusion of depth in a painting you must go beyond linear perspective and incorporate aerial perspective. Linear perspective enables you to understand the way things appear to diminish in size toward the horizon, but it does not take the effects of atmosphere into account. Aerial (or atmospheric) perspective reflects the way that—even on a clear day—dust and moisture particles in the atmosphere filter out some of the warm, red rays of sunlight. As a result, objects appear bluer the farther they recede into the distance. In addition, the atmosphere causes distant objects to appear blurred and indistinct by reducing the contrasts between light and dark.

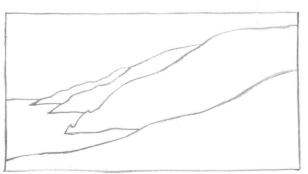

This simple landscape of four spurs of land offers a clear example of atmospheric perspective. Start with a blue outline to set the midtone for the piece.

SHOWING EXTREME DISTANCE

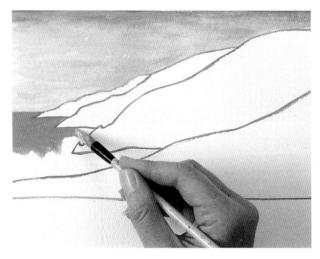

Mix a relatively weak blue with titanium white in varying proportions for the sky and sea. Make the sea darker than the sky.

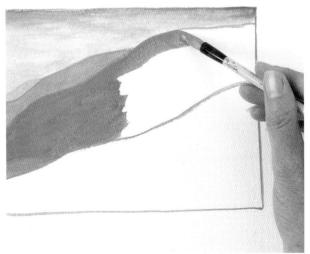

Paint the farthest headland with another mix of blue and titanium white, paler than the sea but just darker than the sky. Paint the next headland with a slightly warmer tone, adding a little cadmium orange. The blue and the orange bring a hint of green to the headland.

artist's note

If you paint outdoors, there will be occasions when you will see warm colors in the distance—cut fields of hay, plowed red earth. In these circumstances, take care to compare these colors with any warm color in the foreground, so that you do not make the distant colors too strong.

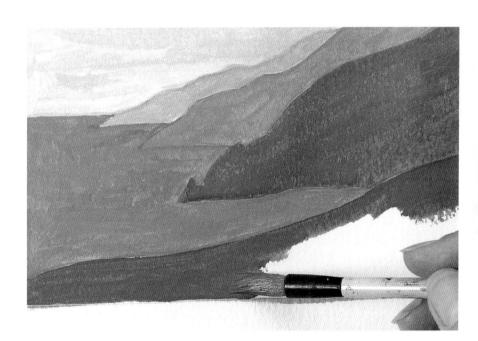

Increase the amount of cadmium orange for the next headland, giving it a much denser and less atmospheric appearance. The green tone is stronger and the colors are more recognizable as those of a grassy cliff top.

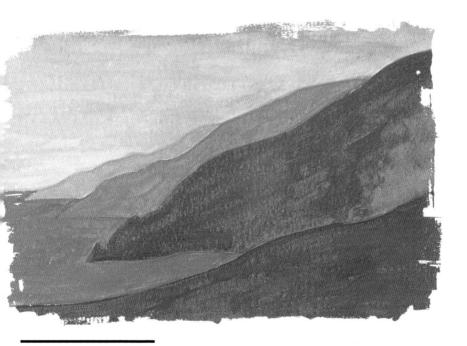

For the immediate foreground, add even more cadmium orange and use no white at all. The completed image has a sense of distance, and a gradual reduction of warmth and contrast toward the distance.

Deciding where to add detail

The amount of detail you choose to put in any part of your painting depends on where the center of interest lies. If you are most interested in the foreground—for example, if you are painting a garden of flowers in front of a landscape—most of your detail would be in the flowers and the landscape would take a supporting role that wouldn't detract from the focal point. On the other hand, if you are more interested in the distant hills, then you would make the foreground more of a suggestion than a fully rendered area, so it did not compete too strongly with the hills. The degree of detail depends on where in your painting you want the viewer to concentrate.

The main area of interest here is not far from the viewer, but half the picture space is foreground. The eye-level is quite high, suggesting an inclined approach to the gate. Use brilliant vellow green for the ground color, and mix titanium white and cobalt blue for the sky; both are pale and cool. Block in the gate with varying mixes of titanium white raw sienna, and black, establishing the painting's strongest colors. Paint the grass in coarsely.

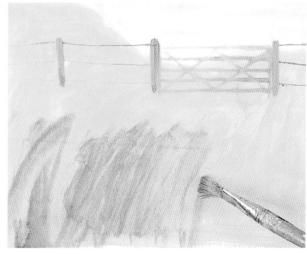

The object of main interest—the gate—is in the upper third of the picture. The large expanse of foreground has a strong supporting role, but it does not overwhelm the effect of the gate. Use soft streaks of paint in the foreground grasses to contrast with gate's fine, crisp lines. Enrich the middle ground with green, but do not let it vie for prominence with the gate.

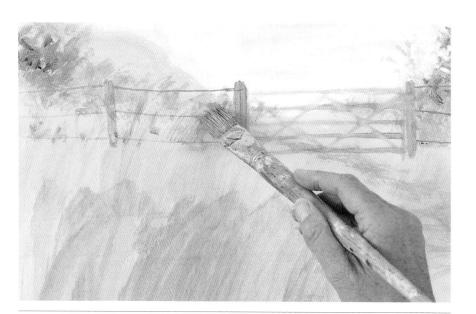

Now add more details and color to further develop the gate and the rest of the middle ground. Add details to the flowers and weeds in the fence with redviolet, cerulean blue, and titanium white. This will draw the eye to the line of the gate without making it jump out unnaturally.

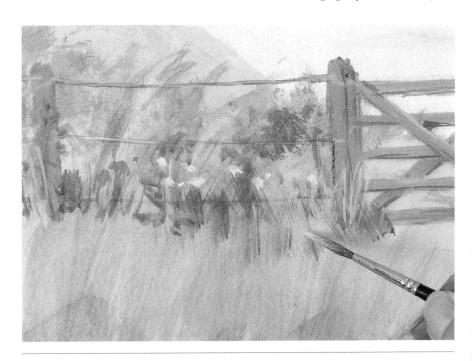

DECIDING WHERE TO ADD DETAIL

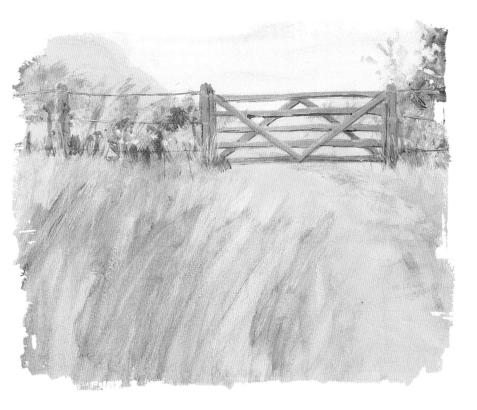

Paint the foreground quite softly, leaving it relatively indistinct. Even though it is largely out of focus, it is still very important, supporting the color and leading the eye to the main interest. Another artist might have concentrated on the foreground grasses and left the gate and fence much less resolved, but this would have altered the balance of the painting and left it much more "bottom-heavy." Although the foreground may be expected to have the most detail, more detail here would have caused the viewer to be drawn to two areas of focus, and the painting would have lost some of its impact.

Painting realistic foliage

Trees and bushes in full leaf create large areas of complicated, confusing textures and closely related colors and tones, which can be very daunting for the beginner. Painting foliage demands a great deal of practice in color mixing, and it is very easy to be drawn into trying to replicate endless detail.

Start simply with one green—preferably a transparent color—and begin by drawing out your composition. Then look carefully to see the differences in other greens in the landscape. Keep your greens clean and do not allow them to blend with one another, either on the palette or on the paper; otherwise you will end up with dull, indistinguishable colors.

Lightly brush a rough transparent area of Hooker's green to denote where the tree is densest. Add thin lines of the same color to indicate branches and sprays of leaves against the light. Paint the darker lines of the plant in the front with the same color but more densely. Now you've created three different and simple foliage effects using a single green.

PAINTING REALISTIC FOLIAGE

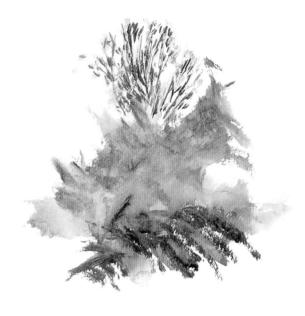

Add cobalt blue to the thin green marks of the most distant tree to give it greater strength. Remember that the aim is to construct this study so that the three main areas are all green but with different variants. from the warm in the foreground to the cool in the distance.

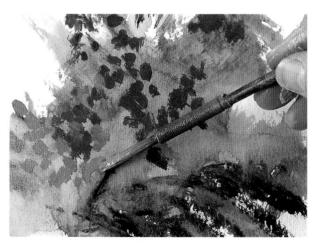

Apply darker strokes of Hooker's green, more opaque than the original underpainting, for the leaves of the center tree that are against the light or in shade.

DEPICTING LANDSCAPES

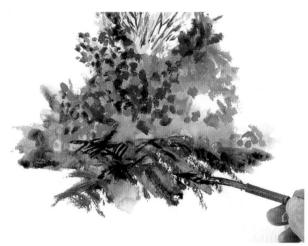

To create an even greater range of foliage, mix a little cadmium red with the Hooker's green. This will make a reddish brown ideal for stalks and bark. Mix the paint so it's thin enough to get a good flowing line for stalks and twigs.

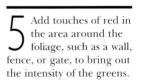

PAINTING REALISTIC FOLIAGE

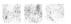

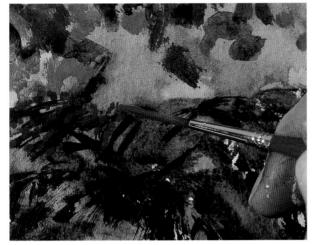

Paint little spots of pure cadmium red for the cotoneaster berries to provide a vivid relief from the greens. The consistency of the acrylic has to be just liquid enough so that you can paint each berry with one dab of the brush.

Add depth and solidity to the branches of the center apple tree using brilliant purple with a little cadmium red. Notice that the greens remain vibrant and separate with no overmixing or muddying of colors. The greens do merge into one another, but the variety of brush strokes and paint densities effectively differentiate the individual tree and shrub by texture and tone.

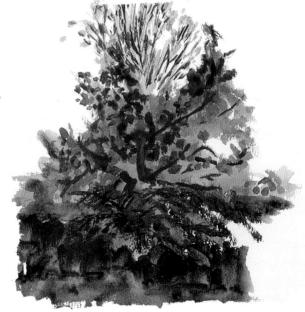

Different types of tree

Make a habit of studying various types of tree; look closely at the structure of the trunk and branches, the shapes of the individual leaves, and the overall shape of the body of foliage. Compare the height and width of the canopy of leaves to the trunk. Note the way light filters through the leaves, and the colors change to denote the three-dimensional form. Make several practice studies and use them as reference while you paint.

The sheer volume of foliage and greens in a landscape can tempt you to simply paint the whole canvas green and then add texture. Begin instead with a mid-tone sketch, blocking out the main areas of color.

Look closely at the variety of color in a landscape, particularly at the areas of blues and yellows. Your trees will need to stand out from the surrounding green areas of grassland and shrubs.

DIFFERENT TYPES OF TREE

Concentrate on the differences in texture between the trees and other forms. Pay attention to the way the light hits the outer leaves and keeps the dense core of the foliage in shadow. This will keep the forms from looking flat and lifeless.

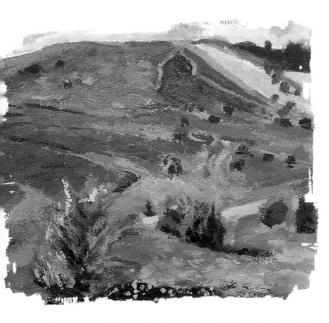

Avoid blocking in large expanses using the same color. Give the impression of different types of foliage with subtle changes in tone and texture, and do not get bogged down by trying to paint individual leaves.

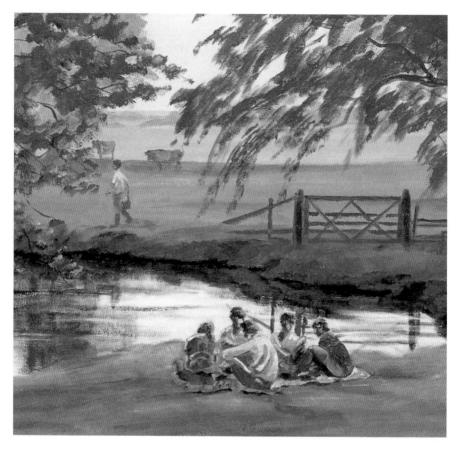

Deciduous trees

This painting incorporates two very different brush strokes. A stabbing stroke creates the fuller, rounder leaves of the tree on the left, while short diagonal strokes in a range of greenish browns create the wispy willow leaves on the right. Note the importance of "sky holes" (negative spaces) between the leaves. Even when a tree is in full leaf, there will be small gaps where the background or sky is visible. Also notice that the leaves follow the lines of the branches, even where they fully conceal them.

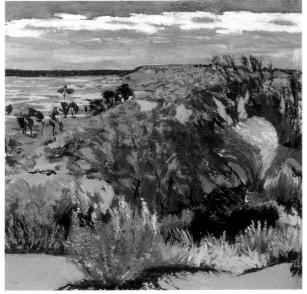

Desert trees

The warm red-browns and rich, dusty greens of desert plants offer a wider color palette and textural range for a landscape painting. The textures contrast wonderfully with the rigid horizon and the stony ground. Here the blues and purples of the desert can be seen lifting the landscape, throwing the reds and greens into relief.

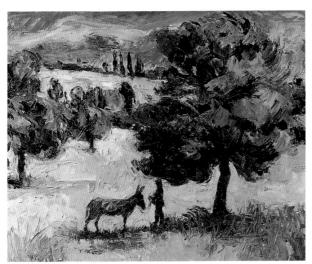

Full summer trees

Broad strokes of color denote clumps of leaves in more distant trees. In such bright sunlight, the core of the foliage and the trunk appear almost black against the yellowed fields. Notice that the color is balanced by a slight repetition of the dusty yellows in the most exterior leaf clusters on the tree.

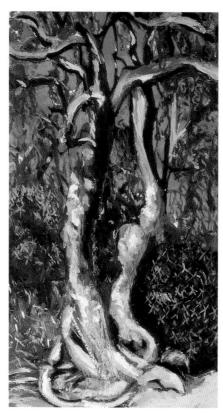

Left: Gnarled trees

Trees are not all about foliage. There are also fantastic lines and colors in tree bark and branches. The incredible convoluted interweaving of the trunk and roots here draws the eye up and through the painting, while restful areas are created by the short shrubby foliage in the background.

Below: Winter trees

Stripped bare, winter trees appear rigid and skeletal in a snowy landscape. The uniformity of color and shape intensifies the distance and breadth of this painting, and throws the icy expanses into harsh relief.

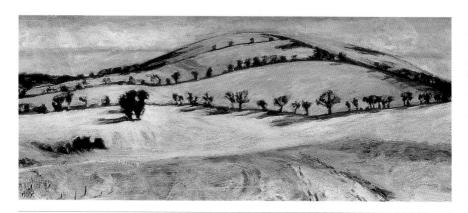

Demonstration: Australian landscape

The painting developed here is from an area of red sand hills in the extreme southwest corner of Queensland, Australia. The intense reds at the horizon, the clear air, and the lack of humidity all give the landscape a clear, crisp quality that challenges our understanding of atmospheric perspective. Other areas of interest include the ground, which is dotted with tiny succulents and thorny plants, and the low trees, mulga, acacia, and eucalyptus in the distance.

The red earth is visible through the thick, scrubby covering, so begin by painting a rich orange as your colored ground. Then draw out the main elements of the composition with raw umber and a long-haired fresco brush.

There is little point in spending a lot of time drawing the grasses and weeds in the immediate foreground because their forms will not create a very dynamic composition. Instead, focus on sketching the bald profile of the sand dune, the bushes clinging to it, and the wiry vertical of the lone tree.

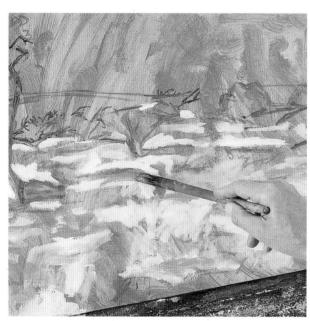

Notice that the dry grasses and seedy, ground-hugging plants are quite pale against the bare earth. The orange base color acts as a mid-tone against which you can establish the extent and general shape of the lighter areas.

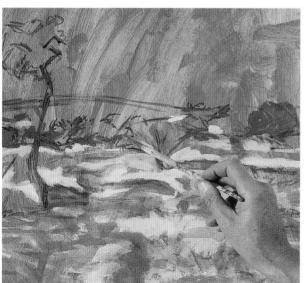

In defiance of the laws of atmospheric perspective, the most distant part of the painting has the warmest color. However, the bushes at the base of the dune are bluer than anything in the immediate foreground. To add a soothing coolness to the deepest part of the landscape, paint these little bushes with cobalt turquoise.

DEMONSTRATION: AUSTRALIAN LANDSCAPE

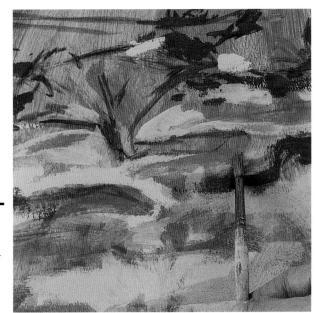

Paint the seed pods of the low-lying succulents with brilliant purple. This color sounds very bright, but it is a ready-mixed tint, combining titanium white and dioxazine purple.

The winter sky in Oueensland is a radiant blue. When skies are blue, they usually contain both bluesreddish blue and greenish blue. In the middle of the day, the reddish blue is in the dome of the sky, while the slightly greenish hue is observable toward the horizon. This is only a rule of thumb, but it is certainly true here. Paint the whole sky area with the greenish blue to start with, using light blue permanent (ready-mixed titanium white and phthalocyanine blue and green).

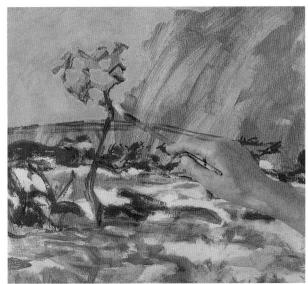

The rugged landscape contains a number of ankle-high plants. Paint them with Hooker's green deep hue; then scratch through the paint with the end of your brush to suggest the dry stems of these low-lying weeds.

To add detail to the dry grasses, make zigzag scribbles with your fresco brush. Giving objects in the foreground more detail than anything in the background will help add a sense of depth to the landscape.

DEMONSTRATION: AUSTRALIAN LANDSCAPE

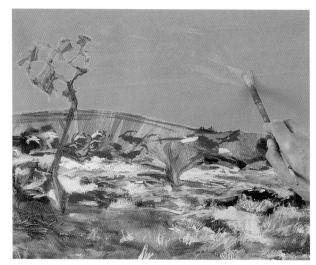

Once the landscape is more established, turn your attention to the sky. To begin to establish the sense of heat. use choppy strokes to paint a band of brilliant purple in the sky. These strokes will eventually become absorbed in a gradation of blues.

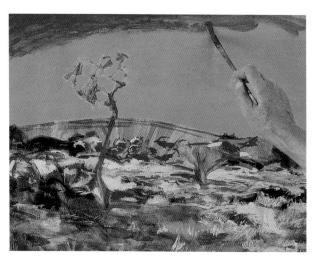

When using a medium with lots of body, such as oil or acrylic, making a gradual shift in color involves some risktaking. Start the gradation by painting an unmixed cobalt blue at the top of the sky, above the band of brilliant purple.

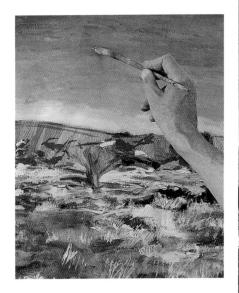

Blend the cobalt blue into the brilliant purple; you will notice that a more subtle gradation begins to appear. Then apply a deeper green-blue variant of the titanium white and phthalocyanine blue and green mixture to create a more brilliant blue in the sky. This color is tonally closer to the cobalt blue/ brilliant purple blend, and it allows you to take the gradation lower down the sky.

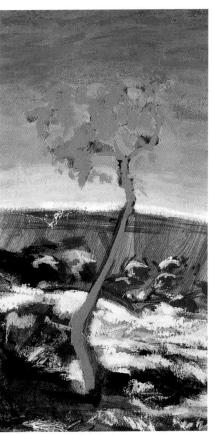

Block in the eucalyptus tree using neutral gray, letting the original underpainting show through.

DEMONSTRATION: AUSTRALIAN LANDSCAPE

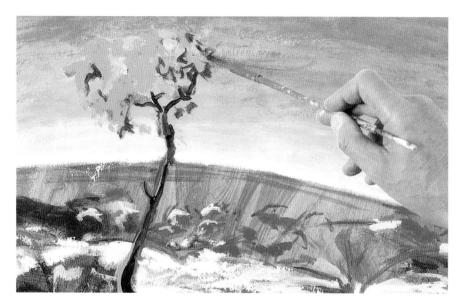

The leaves of trees against a bright sky look quite dark, so establish the darkest tones with Payne's gray, picking out the darker branches as well as the darker undersides of leaf clumps. Take care to trap the "sky holes" in the foliage.

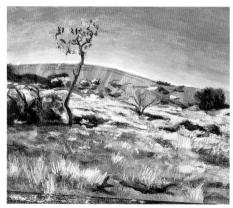

Now the painting is nearly complete. It could almost be left at this stage, but the sand dune is still just the original underpainting. The sky is also too powerful for the orange and overhangs it oddly.

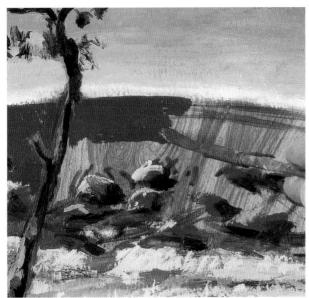

Mix cadmium red with red oxide to make the paprika color of the sand dune. Now the consistency of the paint should be like that of house paint so it will cover well. The strength and opacity of the color will close up the apparent space between the dune and the bushes at its base.

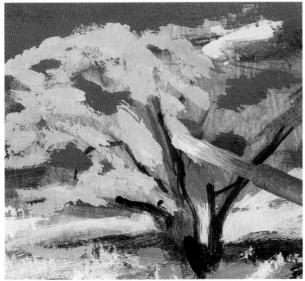

Paint the small, dry mulga tree in the center of the painting with a mixture of titanium white, brilliant purple, and a touch of Payne's gray. Notice how light this shrub appears to be in front of the richness of the sand dune.

DEMONSTRATION: AUSTRALIAN LANDSCAPE

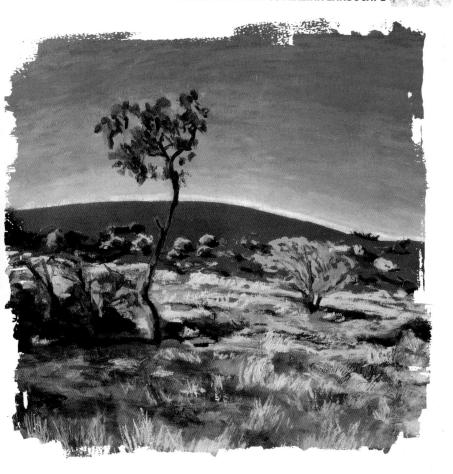

Even though this painting is a light-filled space with few major forms, it has a wide tonal and color range. The darks are dotted about the painting, with the biggest concentration in the shadow under the dead bushes to the left of the eucalyptus. The lightest tones are tops of the weeds and grasses, making them appear to shimmer across the ground. Dominant colors are red and blue, with greens and violets as the smaller subsidiaries.

apturing the essence of a scene or object is one of a painter's greatest achievements. Whether the rough warmth of a brick in the sun or the crisp, sharp outline of a footstep in snow, depicting feeling or texture convincingly will take your paintings to a new level. When you have mastered duplicating the colors and moods of different types of weather, there will be little to daunt you in any landscape, townscape, or seascape—no matter where you are in the world or what the season happens to be.

Portraying weather, atmosphere, and temperature requires a clear understanding of color and form. From the harsh shadows of midday to the subtle shapes of cloth in wind, careful observation of the way the light changes and how forms conform to those

changes are paramount for painting realistic images. Indeed, you must master the skill of painting the invisible, whether it be wind, heat, or cold.

Try not to overwork your paintings. Often subtlety and impression can have a greater impact on the viewer than forced detail. Practice painting small, detailed studies of various surfaces, noting the effects you can achieve with differing brush strokes and color combinations. Don't discard your studies, even if you are not happy with them; they will make useful references for future paintings. And don't get discouraged. These refined painting skills may appear difficult to master, but when you have attained the skill, there will be nothing you cannot paint.

Depicting strong sunlight

Sunlight can be so powerful that reflected light from it can illuminate shadows until they glow with color. To capture these effects in a painting, carefully observe the relative values of tone and color. And be prepared to be surprised by the way that colors you think you understand are radically altered by the sun. Bright lights aren't the only result of strong sunlight; shadows are also highly intensified and enriched by it.

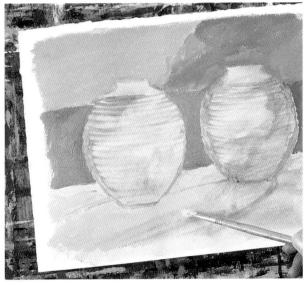

This painting demonstrates the effect that strong reflected light can have on white. Paint the background with a mixture of medium magenta, cobalt blue, and titanium white. This will complement the bright, pale ocher that will dominate the finished painting. Block in the greenery behind the pots using variations of a mix of phthalocyanine green, Turner's vellow, and titanium white. Use burnt sienna and titanium white for the foreground.

DEPICTING STRONG SUNLIGHT

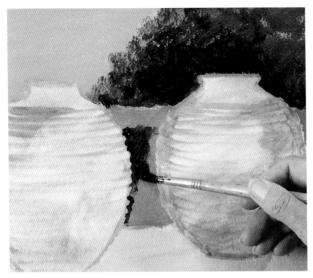

In the bright light, the shadowed side of the hedge is very dark. Paint this deep green with a mixture of Hooker's green and cadmium red deep. The dark shadowed green clearly defines the grooves in the sides of the pots. Further delineate them with a deeper mixture of the color used for the ground.

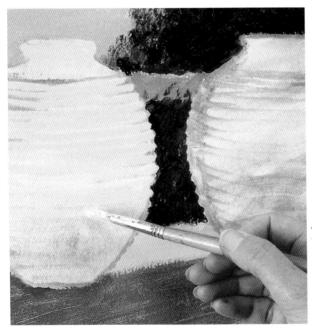

Paint the first tint of ocher in between the violet stripes, giving the pot more substance. Use unmixed yellow ocher, thinned with enough water to make a nice flowing line. Create the rich shadow of the pots on the ground with the underpainting mixture but with more cobalt blue. While it is still wet, brush in streaks of yellow ocher so the shadow does not appear too uniform.

CREATING ATMOSPHERE AND TEXTURE

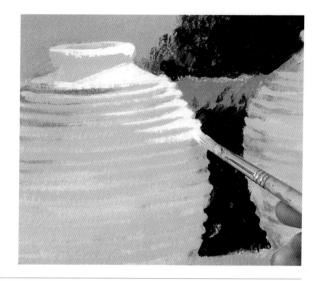

Accent the strongly lit white edges with a layer of thick titanium white. Notice that the yellow ocher stripes stop short of the left-hand edge, so the violet remains the shadow color.

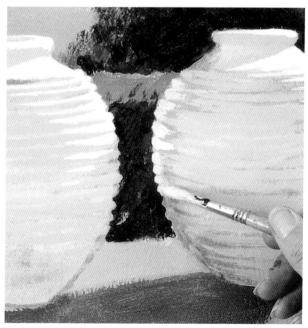

Very strong light will create equally strong reflections. Here, the left side of the right-hand pot is picking up a very strong reflection from the other pot. The violet shadow from the neck is quite luminous. Tonally, there is not much difference between the yellow and the violet, which adds to the overall glow.

DEPICTING STRONG SUNLIGHT

The sky is left as a violet underpainting to make the ocher glisten and add to the feeling of summer heat. Add a final layer of broken strokes to the sunlit area of the ground using a mixture of yellow ocher, titanium white, and a little touch of cobalt blue.

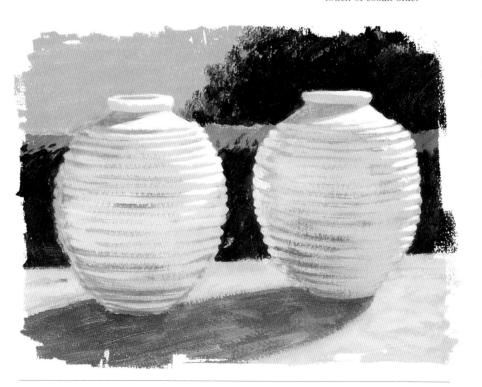

Fluffy clouds with depth and dimension

The greatest difficulty with painting fluffy cumulus clouds is giving them size and visual impact without making them too solid and heavy to float in the sky. To be convincing, clouds must seem to defy gravity yet still follow the rules of perspective. And, even though they may be very bright, they must still have their own shadowed side. Unlike thin, wispy clouds or sky-covering rainclouds, fluffy clouds appear to be separate from the sky rather than integral to it. To achieve this effect, paint the clouds on top of the sky background.

Paint the sky with two blues—a warm (light blue-violet) and a cool (permanent light blue). This will give the sky a sense of depth.

FLUFFY CLOUDS WITH DEPTH AND DIMENSION

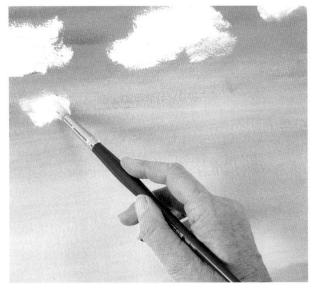

Start painting the clouds with a semi-opaque mixture of titanium white. The mixture shouldn't be too dense, or the clouds will look too solid to be convincing. Use a denser mixture in the center of the clouds and brush thinner, less opaque white outward at the top, giving the clouds a fluffy, gently windblown appearance.

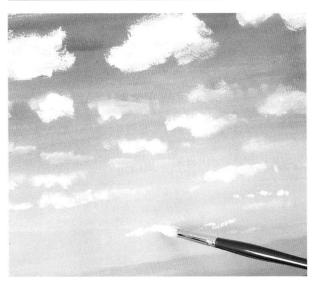

Make the clouds smaller as they get closer to the horizon. Using just the tip of a fine bristle brush, paint the smallest clouds with a very diluted titanium white. In this flat, open landscape, you can easily see that the size of the clouds diminishes as they approach the horizon. Also, the contrasts in tone within each cloud are much less apparent on the more distant clouds.

CREATING ATMOSPHERE AND TEXTURE

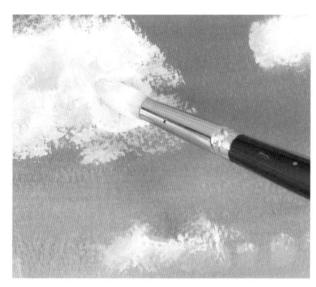

To create a three-dimensional look, add a thin, neutral gray to the nearest clouds, delineating the areas of shadow and adding a feeling of volume.

The final stage shows depth quite convincingly with very simple means. Not only is there the perspective of scale, but there is also atmospheric perspective. The nearest, biggest clouds contrast more with the blue than do the small ones that are at the horizon.

FLUFFY CLOUDS WITH DEPTH AND DIMENSION

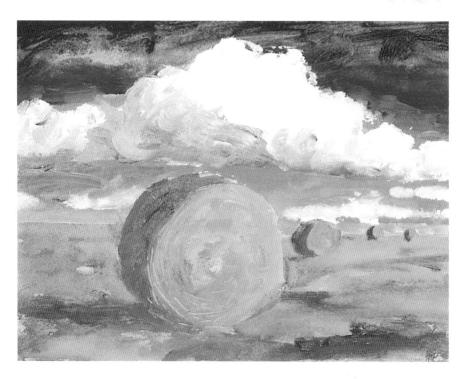

Summer clouds

In this simple landscape, the main cloud in the foreground has a huge focal impact, almost more than the main hay bale. The clouds receding into the distance also mirror the receding bales, giving the painting a lovely balance. Notice the extent to which the blue of the sky pales toward the horizon, so the palest part of the cloud is in the darkest part of the sky. This greatly heightens the effect of depth and distance.

Creating the impression of a windy day

Flags, treetops, wheat in a field, umbrellas, slanting rain—many things can be painted to capture the impression of wind. Like light, however, wind can be expressed only through the effects it has on other objects. Just as you would consider a light source, think about the direction of the wind and the effect it has on the items it moves. Wind affects different items in different ways—billowing light cloth, flattening foliage—but it is unlikely that wind blows in two directions at the same time. Make sure that your wind direction is consistent, but don't allow this to make your painting static.

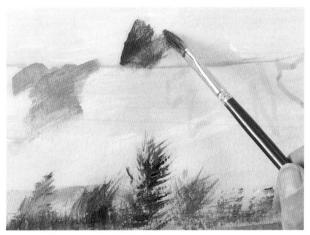

Place stationary secondary objects in the foreground or background to help to create the impression of light wind. Paint this landscape briskly with flicking brush strokes and varying mixtures of Hooker's green and yellow ocher.

CREATING THE IMPRESSION OF A WINDY DAY

Add the laundry in an almost unfinished style, with strokes that do not completely define each garment. Let the diagonal strokes of the blue shirt on the left seem to break and melt into the sky. This emphasizes the movement caused by the gusting wind.

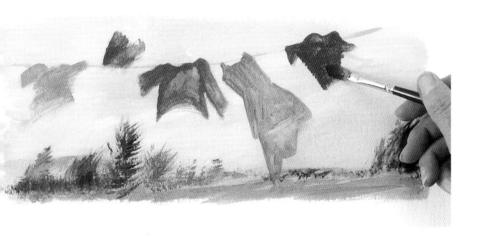

Block in the other garments with varying mixtures of cadmium red deep and cerulean blue. The wind is clearly coming from behind the clothes, blowing them toward the viewer. Painting the clothes at odd angles highlights the way each garment responds to the wind; they seem to dance against the pale blue sky.

CREATING ATMOSPHERE AND TEXTURE

The wind has blown inside the dress; with its added volume it picks up more variations of light and dark than the other clothes do. The parts of the garments that are nearer the clothesline are more static and hold their shape more clearly, just as a flag on a flagpole does.

The light brush strokes and transparent tones used in areas like the shirt on the left and the bottom edges of the dress give the clothes an indistinct quality and create the impression that they are being whipped in the air by the wind.

CREATING THE IMPRESSION OF A WINDY DAY

artist's note

These simple rules can be applied to all clouds. Increase the size and degree of shadow and dark tones for cumulonimbus storm clouds. Repeat the delicate strokes of the distant clouds in the foreground for high, wispy cirrus clouds. Add Payne's gray to the blue of the sky to create an overcast, rainy atmosphere.

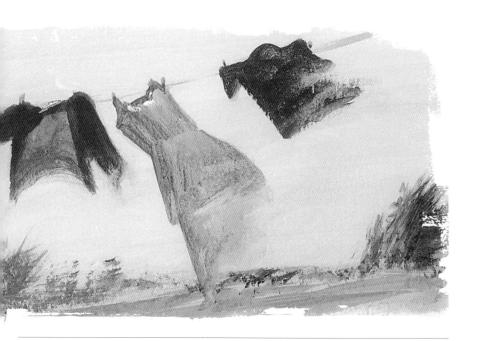

Recreating the atmosphere of a misty day

Painting mist is often more about painting what is not there than what is visible. Edges and spaces are soft and merge into one another, light diffuses rather than defines objects, and colors are muted. Objects that are normally solid and substantial become ghostly, while shadows are almost entirely absent. The vagueness and softness of damp atmospheric effects can cause a painting to look washed out or insubstantial, while painting any element too strongly will throw off the balance of the piece and lose the lightness you want to achieve.

To paint the light of the mist positively, rather than just using the white of the paper and an absence of pigment, prepare a colored ground. Here, a mixture of brilliant purple and Payne's gray creates the pale blues of a winter sky. The cold dampness is reinforced by the foreground underpainting of Hooker's green and quinacridone burnt orange.

RECREATING THE ATMOSPHERE OF A MISTY DAY

artist's note

In misty conditions, colors are gentle and subdued. Control your palette carefully, using the minimum of tonal contrast. This will help you to maintain a soft tone without allowing the picture to dissolve into a meaningless blur.

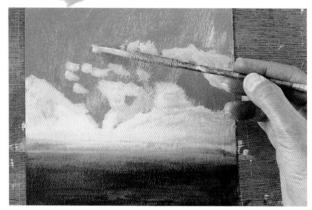

'Carve" the main shapes with a paler mix of the sky. Start the painting at the horizon and keep the forms pale and indistinct. Work gradually toward the foreground, steadily increasing the depth of tone and intensity of color.

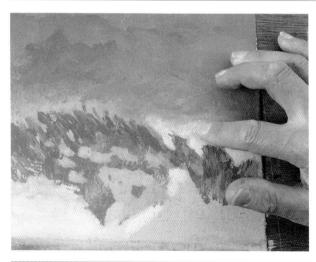

Too much detail and too many hard edges will ruin the ethereal effect of the mist. To take the sharpness out of the edges, smudge the paint with your fingers. This will also help you resist the urge to add detail to objects in the mist.

The colors and distinction of form are stronger in the foreground, but the mist does not stop suddenly. To capture the effect of ground-hugging mist, rub it into the underpainting with your finger.

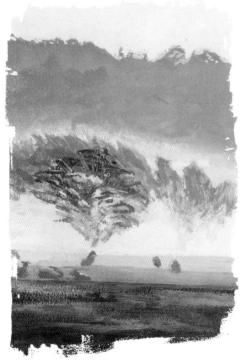

Use deeper variants of the same color mixtures (with a higher proportion of Payne's gray) for darker areas of the painting, such as the heart of the main tree. Paint the contrasting color of the sky above the hill with titanium white, yellow, and a tiny bit of violet to take the sharpness out of the yellow. The contrast between the strong tones in the foreground and the weaker ones in the distance will accentuate the illusion of depth and space. The stronger foreground tones will also anchor the painting and make the misty areas appear softer, creating a misty country morning scene.

What is a good exercise for learning to paint snow?

The beauty of a snow scene is its striking patterns of light and dark. Look for opportunities to use strong tonal contrasts, such as the dark lines of a tree against the light snow and sky. A landscape covered in snow will be punctuated by the dark tracery of tree branches, the blackness of roads—even the paths made by walkers and animals will look dark, breaking up the mass of white.

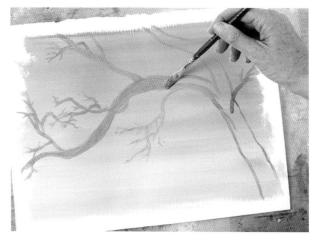

Prepare a thin, blended wash of phthalocyanine turquoise and titanium white. Block in the shapes of the branches with a mix of raw umber and titanium white. You want a good mid-tone ground that will highlight the strong lines of the bark texture and later enhance the whiteness of the snow.

Paint the dark texture in the bark on the underside of the branches using a fine rigger brush and a mixture of raw umber and dark blue. Create a bold linear pattern that follows the line of the branch. Notice that the offshoot on the left comes forward in the painting, because it has just a bit more solidity than the branch behind it.

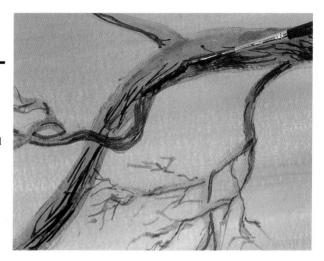

With the tree branches rendered, you need to balance the dark textured branches with the soft snow. The branches form a very dark ground which will need to be painted over with white for the snow.

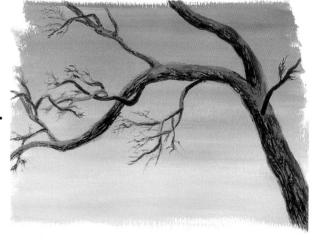

WHAT IS A GOOD EXERCISE FOR LEARNING TO PAINT SNOW?

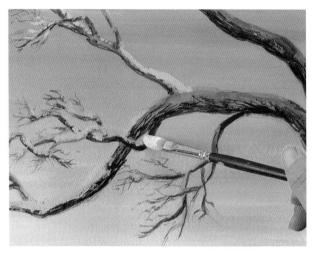

For the first layer of white for the snow, mix a blue-white with titanium white and a touch of ultramarine; this will serve as the shadow tone. Apply it thickly and unevenly to break into the bark texture at the edges.

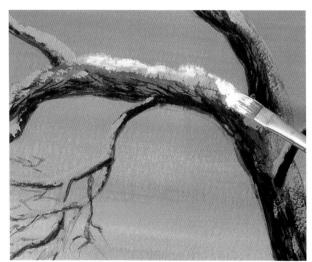

Next paint another layer of white on top of the bluewhite—this time a mixture of titanium white and gold ocher. This creates a warmer white for the brighter, light-catching snow. Again, apply it unevenly so that the bluewhite shows through.

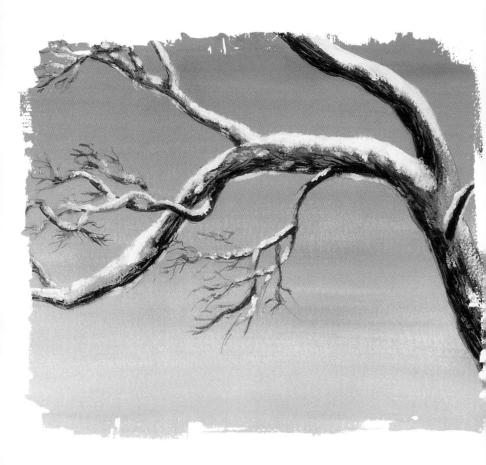

The snow in this study is painted with a mixture of cool and warm tints so that it sits on the cooler, darker tree branch but also integrates with its texture. Notice that the streaks of snow appear to have been driven into the bark on the branch as it rises up from the bottom-right corner.

Demonstration: Snow scene

For a painter, the most surprising thing about snow is that it introduces such an extraordinary quality of light into a picture. The lightest part of an expanse of snow can send bright, reflected light that illuminates areas normally in shadow. Painting snow

does present challenges, one of which is how to give the whiteness physical presence.

Painting white paint on a white ground is not very rewarding, so create a light blue-violet colored ground with a mixture of titanium white and ultramarine. Then sketch the composition with quinacridone gold, delineating the main edges and shapes.

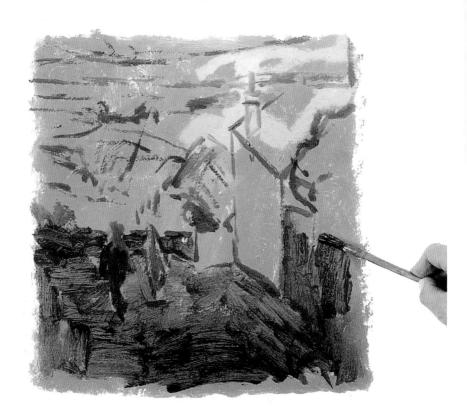

Although much of the foreground will be snow-covered, block in the bottom half of the picture and the shapes in front of the end wall of the building with a translucent mix of ivory black and matte medium. This will add depth to any strokes that later show through the snow. It will also ensure that you have to apply the white generously and drag the paint over the matte surface. Continue the black mix over the detail in the background.

DEMONSTRATION: SNOW SCENE

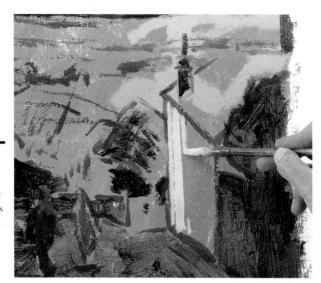

The sunlit wall is the only large area of warm color in the painting. Paint this loosely in light pink. Blocking this area early on will give you a reference point for the cooler tones in the rest of the landscape.

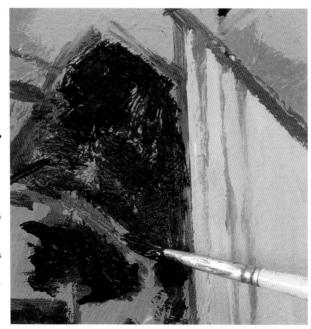

Next, block in the darkest tones, such as the area of dark shrubbery behind the building. Blocking in the brightest and darkest tones allows you to judge the balance of the values in your painting. Snow scenes invariably contain strong contrasts of light and dark, and these contrasts will add depth and brilliance to your snowy landscape.

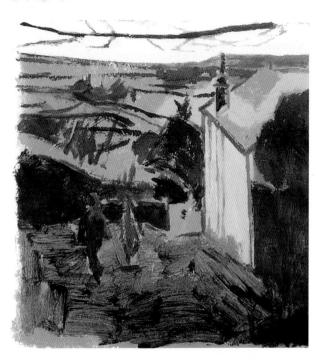

Two other strong contrasts here are the pale distant sky and the strong dark lines of the branch extending across it. Paint the branch and the other trees and bushes in the landscape with a mixture of Hooker's green and ivory black. This will anchor them in the snowscape and give the appearance of solidity.

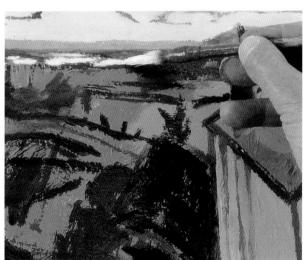

Pick out the shapes of the distant fields with a thick application of titanium white, and leave traces of the blue underpainting to help give a sense of distance and atmospheric perspective.

DEMONSTRATION: SNOW SCENE

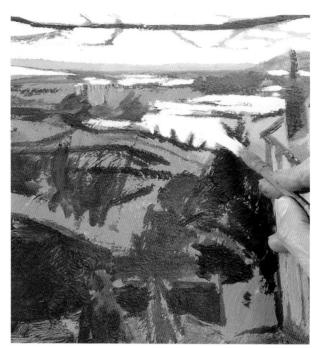

Continue to paint the nearer fields with titanium white. As you paint increasingly nearer the fields, completely block out the blue underpainting with white. Leave the darker areas untouched, particularly the uprights of the trees that are in the middle distance.

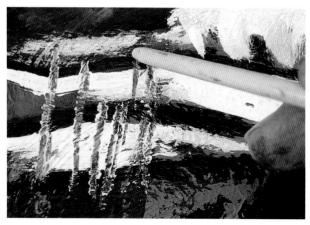

To achieve the harsh lines of the middle-distance tree branches, score through the wet paint with the handle of the brush to reveal the underpainting. As you scratch with the point of the brush handle, drag the white paint across the dark lines of the field behind the tree to add further texture.

The middle ground, where the hedge and wall cut across at the

bottom of the foreground field, must be carefully defined. Paint white "holes" in between the leaves of the thick ivy and then apply white around the rest of the wall to separate it from the row of trees behind.

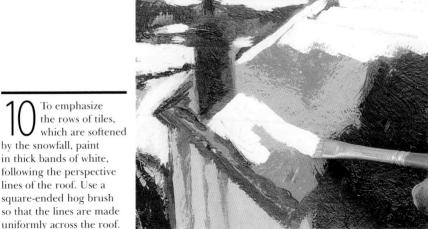

by the snowfall, paint in thick bands of white, following the perspective lines of the roof. Use a square-ended hog brush so that the lines are made

DEMONSTRATION: SNOW SCENE

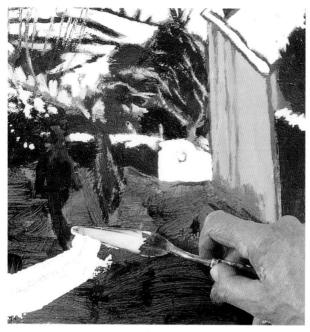

Next, apply a thick layer of white to the foreground with a painting knife, leaving only the figures to the left of the path unpainted. Also add snow to the top of the wall behind the figures. This gives depth to the painting and highlights the fact that the figures are two small points of color in this landscape: a focal point of the painting.

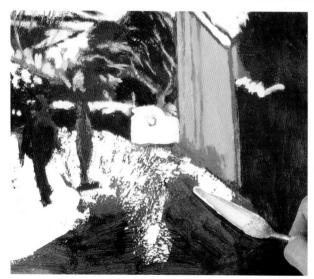

Now add thick snow to the foot of the building. On the path in between the figures and the building, drag a little white paint into the base color with a painting knife.

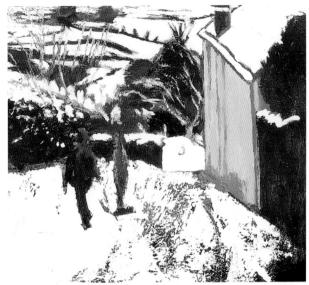

1 3 Use the painting knife to make textures as well as to apply thick paint. For example, for the impression of tracks in the snow, drag the knife and the paint to create a rough, textured area.

Add further texture to the snow on the path by scratching over the area with the tip of the brush handle. There is enough body to the paint to stand out crisply against the small patches and creases of dark underpainting and create a convincing area of flattened snow.

DEMONSTRATION: SNOW SCENE

15 Stipple the stone wall with a mixture of quinacridone gold and Hooker's green.
This mottled pattern will resemble uneven patchwork.

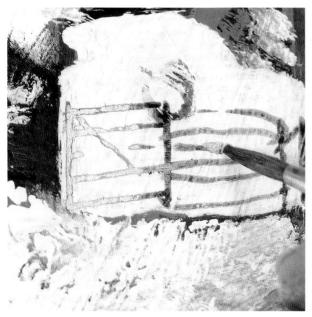

Next, paint in the fine lines of the gate behind the figures. Add texture to the gate between the building on the right and the wall on the left by again scratching through to the underpainting, and pulling the brown of the gate into the white of the snow.

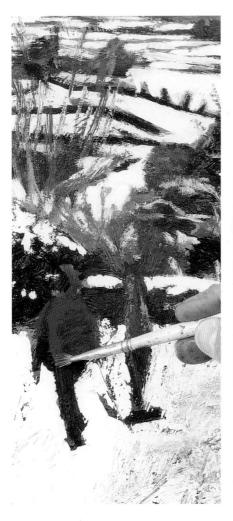

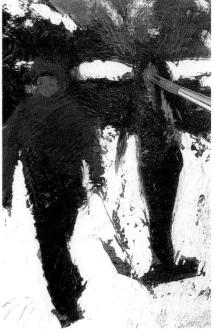

The figures are almost silhouetted against the white snowscape, their darkness merging with the dark wall. Paint the blue jacket with a mixture of cobalt blue and ivory black. The bright jackets will make the figures more prominent.

Paint the jacket and hair of the right-hand figure with Mars violet, and paint both faces with a mixture of Mars violet and titanium white. A slightly blurred effect will give the impression of figures in motion against the static background.

DEMONSTRATION: SNOW SCENE

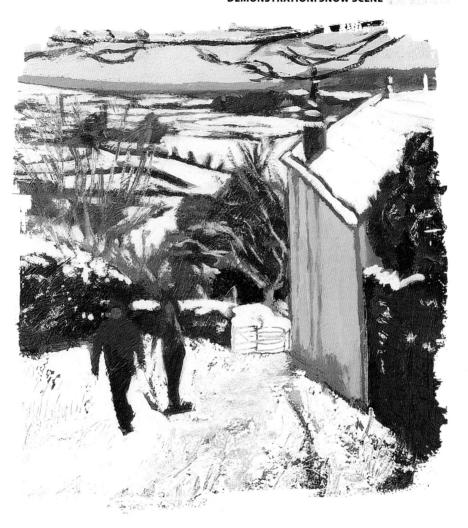

The bright, crisp colors of this snowscape create the impression of sunlight on the snow. The figures add dynamism and color to the composition, and the varied textures and tones of the trees through the snow give a feeling of distance and space.

Recreating textures of wood

Wood offers almost endless varieties of texture and color. Trees and logs have interesting patterns of bark, machine-hewn boards display natural grains as well as saw cuts and tool marks, and the various types of wood have different shapes, knots, and burls. The key to recreating these colors and textures—like anything else—is to observe the subject carefully and paint just what you see. Whether you're painting rough, weather-beaten planks on a house or driftwood on a beach, the techniques are the same.

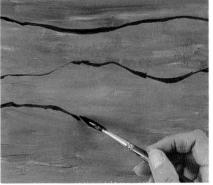

Mix raw umber and white, but don't blend them thoroughly. Use a large flat hog brush and apply the paint in a series of strokes from left to right, letting the streaks show to resemble the wood grain.

Paint the meandering line at the edge of each plank using ivory black, diluted sufficiently to create a flowing line. Vary the thickness of the lines to suggest the differing thicknesses of the wood.

RECREATING TEXTURES OF WOOD

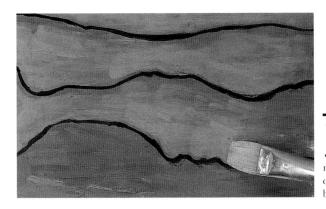

Paint the broad surfaces of the planks using a well-diluted neutral gray. The thin color allows the streaks below to show through.

Scumble titanium white—in a much drier consistency—over the planks. Leave the underlying color exposed close to the lower edge of each plank to create the shadow of each overlap.

Before the titanium white dries, use the handle of the paintbrush to scratch the pattern of wood grain into the paint. Penetrate through to the first color in places to vary the grain.

To emphasize the shadow where each plank overlaps, add diluted Payne's gray with a fine sable brush. (Wash sable brushes thoroughly after use, as dried acrylic paint is very difficult, if not impossible, to remove.)

At this stage, the painting lacks the richness of wood and looks a little cold. At any time, if you know the painting isn't quite right but aren't sure what to do, put it aside for a while. Often seeing it with a fresh eye will help.

RECREATING TEXTURES OF WOOD

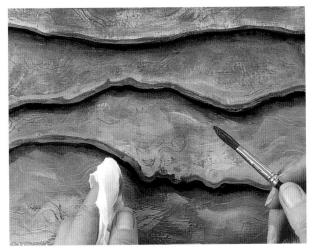

Glazing with a transparent color is an easy way to change the warmth of color in a painting. Add a glaze of raw umber and rub it out in places to add warmth. This will imitate the irregular wear and tear caused by the elements.

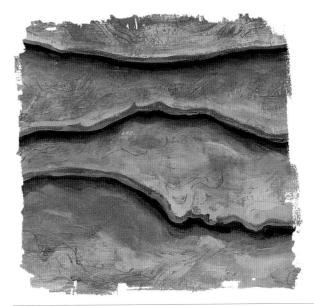

The surface looks warmer and more wood-like following the application of the glaze. You can add more wood grain, if you like, by scratching through to the previous layer of paint.

Precisionist style

Pieces of machinery, cogs, wheels, and the sheen of metal and oily surfaces can make engrossing subjects for a painter. Artists like Fernand Léger and Charles Sheeler loved to paint industrial subjects. Sheeler painted factories and locomotives, and he was part of an association of American artists known as the Precisionists who were attracted by the detail and precision of machines as a subject. Others, like Léger, were more interested in the simplified forms that machines suggested. The following demonstration is an example of this art.

First apply an overall glaze with a mixture of raw umber and cobalt blue. Then sketch the outline of the machinery with thinned ultramarine. Scumble in the base colors, allowing the background glaze to show through to tone down the base colors.

Start to gradually build up light and shadow on the blades of the machine. Several layers of color may be needed before the metal surface is properly rendered. Pick out highlights with titanium white for a tonal reference to compare against other areas of light and dark.

PRECISIONIST STYLE

Add the darkest shadows—the other end of the tonal scale—with a mix of raw umber and dark blue. The two extremes of tonality have been established, so now all the tones in between can be gauged accordingly.

The blades of the turbine present an interesting series of curves that catch the light most strongly at their edges. Paint the broader part of each blade in a mix of red oxide and yellow ocher, lightened with titanium white. This creates the impression of depth, giving the blades a three-dimensional quality.

Soften the edges of the blades with your finger. Rub the warm, light tint away from the edge of each blade and toward the dark shadow, letting the colors blend into each other.

Using a rigger brush, paint fine lines with a mixture of titanium white and dark blue to the hawser around the rim. Make the rim of the wheel warmer and slightly more opaque by applying thinned yellow ocher. This is still a provisional color at this stage, which will need to change further once the rest of the turbine is more fully rendered.

Paint the hub with a mix of cadmium red and raw umber. Apply it softly and smooth the color into the darker tones so that the edges are not too sharp. Apply a final coat of titanium white to the rim of the wheel to create a strong. opaque white against the muted tones around it. This creates the illusion of depth and convinces us that the rim is a solid piece of steel.

Paint the detail on the edge of the turbine with a less opaque titanium white and soften the edges at the rim. Apply final touches of titanium white as highlights at the side of the turbine, but leave traces of the blue to give the impression of shade. This appears to be a remarkably limited palette for a painting. But we know that it contains three reds. three blues, one yellow, and a brown. For such a strong tonal painting, it is surprising that neither black nor Payne's gray was used.

Incorporating different textures

It is very satisfying to produce a painting so richly textured that all sense of the paper, board, or canvas is lost, and only the painted surface is apparent. Taking a close-up view of still life objects, landscape elements, or architectural subjects provides the opportunity to thoroughly explore textures. In addition to observing the effects of light we can also look for areas of uneven surfaces and physical roughness, such as bumps and ragged edges. Brickwork, tiles, shingles, cobblestones, stone walls, and concrete blocks all have their own unique and interesting physical qualities. The example here shows how to build up a convincing representation of the dry, rough quality of bricks and mortar.

INCORPORATING DIFFERENT TEXTURES

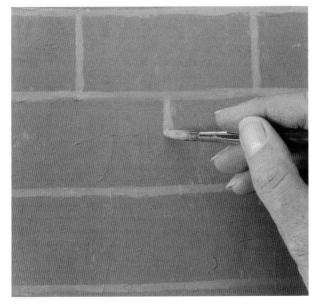

Using a pointed bristle brush, paint the grout with neutral gray, which appears cool against the orange. When doing line work, it is important for the paint to have a flowing consistency, or you will have to stop continually to load your brush. If you do not have a very steady hand, draw the lines with a pencil and ruler before following the drawn lines with your brush. Bricks and mortar are not absolutely straight-edged, so a little wavering does not matter.

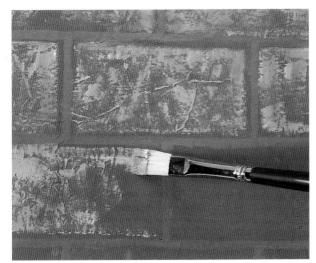

Scumble by dragging a dry mix of orange and titanium white over the first color to make the irregularities of the texture paste more apparent. Now you can already see the beginning of the dry-looking texture of brick.

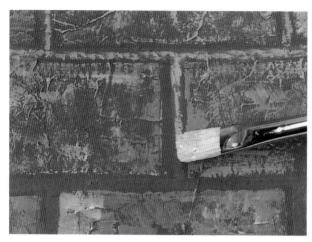

Scumble the same color onto the mortar to add light and texture. Keep the lighter mix in the center of the lines to keep the shadows at the edges of the bricks.

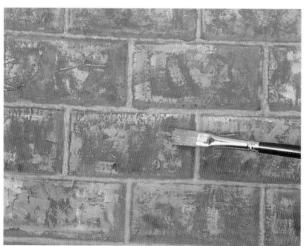

Use a square, flat brush to drag a final, darker mix of orange and neutral gray onto the brickwork to give a subtle suggestion of light coming from the top left. Take care that the color mix is not too wet when scumbling, or this technique will not work.

INCORPORATING DIFFERENT TEXTURES

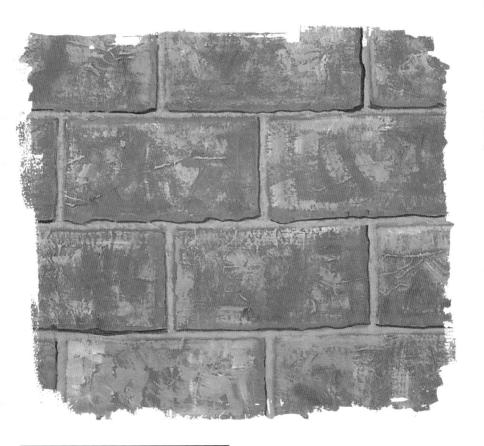

The completed work has a convincingly rough texture. Acrylics are tough enough to use in a similar way to create decorative effects in your home and to paint faux tiles or brickwork on walls or ceilings.

ater is one of the most popular subjects for painters, whether in the form of seascapes, rivers, rain puddles in cityscapes, or woodland pools. How to recreate the colors and effects of water, however, is often poorly understood. Though we may think of water as transparent, often the most opaque colors are required. Imagine the rich greens and vivid blues of the ocean in sunshine, the paler artificial colors of an indoor swimming pool, or the bright, illuminated reflections of store-fronts on a wet road.

Visually, water is created by reflections, and these reflections of shape or color are distorted by the surface of the water. To capture its essence, you must depict the interplay between water and its surroundings.

There are many elements that affect the interplay of textures, lines, and colors in water paintings—the meeting of sky and sea at the horizon, the angle of the sun or moon in the sky, the reflection of trees or boats on a lake, the effects of mist, ice, or, most importantly, wind—all impact on the surface and color of water. Also, within a body of water, there are divisions made by waves and ripples, reflected clouds, and plants or seaweed below the surface—all of which require integrating to create a single mass of water, without it losing its essential fluidity. For a painter, this problem can be resolved partly through close observation of the patterns on the surface of the water and partly through subtle, practiced, and considered color mixing.

Painting ripples

Even the calmest water is often disturbed by ripples. The slightest breeze or the tiniest current can create surface ridges and hollows. That is what ripples are—ridges rising above surface planes or depressions scooped in it. But when we look at ripples, their patterns are complicated by reflections, color, and the direction of the light. Simplification is the key to painting ripples.

To create a convincing body of water, it is vital to prepare the underpainting accurately as this will do much of the work. The underpainting establishes the color composition and the illusion of distance and depth. For this study of a calm lake surface, start with a wet application of bright aqua green, similar to a watercolor wash.

PAINTING RIPPLES

Paint the underlying system of ripples first, using a deeper concentration of cobalt blue over the entire wash. Make the bands broader in the foreground, diminishing irregularly into the distance. Make the consistency of this paint richer than the underpainting but still quite dilute.

To capture the intensity and depth of the ripples, add simple strokes of a darker blue, again, broader in the foreground than in the distance. Select a blue that is not overly powerful, so that it is easier to control when subtly darkening other blues.

PAINTING WATER

Next, add short strokes of a slightly grayish, silvery tone to represent the light filtered through the water. Use a mixture of titanium white, cobalt blue, and red-violet. This tint appears both light on the cobalt blue foreground and dark on the bright aqua green background.

Add highlights to finish your ripples. Use titanium white, thinly applied, to allow the underlying color to come through in places. Throughout, the brush strokes should be kept slightly feathery, not too perfect, in order to maintain a sense of change and motion.

PAINTING RIPPLES

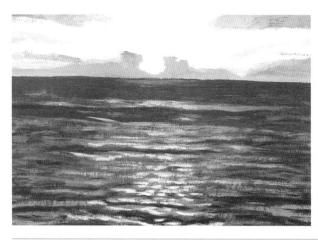

Choppy water

The larger the ripples are on the surface of the water, the greater the difference in the thickness and tone of the bands of color.

artist's note

When painting such a shifting surface, keep a rag ready to wipe off and soften the paint, or use your fingers or a stiff dry brush. You can also use thin white or a nearly white color mixture to trace any light-catching ripples; then dab them off with a cloth to keep them from being too hard and regular.

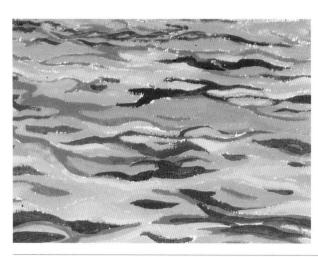

Calm sea

The same rules apply to any body of water with ripples: the intensity of ripples increases in the foreground. Here, the light on the ripples from the setting sun offsets the inky depths of the sea.

Painting reflections on water

How reflections on water appear depends on the light and the water surface. Still water can act as a mirror, accurately reflecting details. But moving water causes reflections to break up and distorts the image of a reflected object. Keep that in mind, and then paint what you see. Remember that a sound composition is the basis for any successful painting. When tackling reflections it will help enormously to initially prepare a clear drawing of the whole scene. Then you can make sure the reflections and the reflected objects are accurate and work together in the composition.

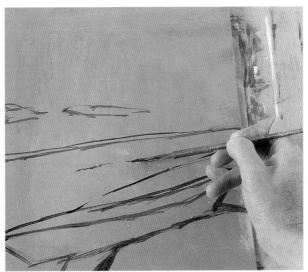

A dilute blue base color is ideal for painting fluffy clouds in a rich blue sky and their reflections in water, because it is not too powerful or sharp. It sits back in the picture space and does not fight with the reflections.

PAINTING REFLECTIONS ON WATER

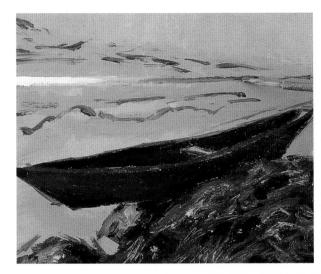

Paint in other areas of color first, as these will also affect the reflections. Then concentrate on the horizon line—the dividing line between the water and the land or sky that will be reflected in it.

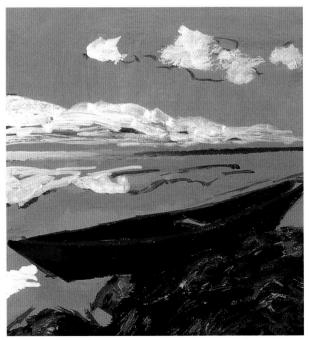

Block in clouds and their reflections with titanium white. To capture the shifting quality of the clouds and their reflections, paint solidly in some areas and less so in others. The quietness of this scene is due largely to the smoothness of the blues in the sky and water. Agitated brush strokes make a painting busy, so keep your brush marks to a minimum by using opaque color mixes and do not over-dilute your paint. A creamy consistency to your color is best for smooth finishes. Against the calm blue of the sky and water, the clouds can float and shine.

Now add depth and tone to the clouds and their reflections. Water tends to deepen light colors and lighten deep ones, so paint your reflections accordingly. Also remember that, on calm water as here, the reflections should mirror the objects.

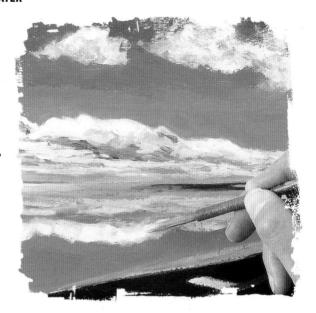

Trees in water

Here the movement of the river breaks up the reflection of the tree on the bank. The reflection has some of the shape and color of the tree, but both are diffused by the light sparkling on the choppy water surface.

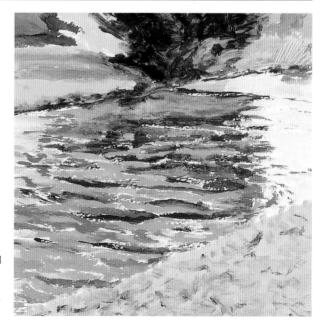

PAINTING REFLECTIONS ON WATER

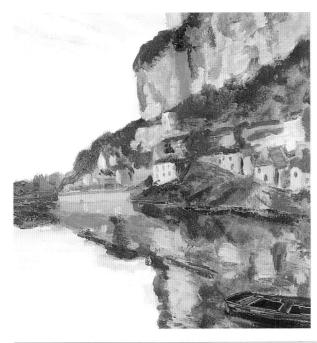

Still water

Here is an excellent example of the way calm, almost motionless water acts as a mirror. The reflections are exact duplications of the land and the sky.

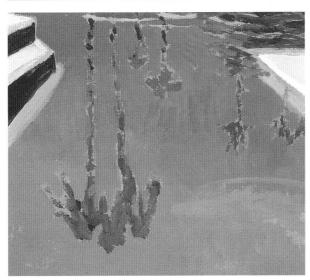

Swimming pool

Sometimes only an impression of distant objects is reflected—particularly in very bright light, relatively shallow water, or water with a strong color itself. For example, in a swimming pool, the water reflects the colors of the pool walls also.

Demonstration: Waves

Wave action can be extreme—even violent. This explosive movement can be difficult to capture in paint without deadening the action or making the swells appear too solid and unrealistic. But you needn't apply the paint thickly

to portray the fullness of the waves. Nor do you need to paint aggressively or quickly to capture the momentum. As always, careful observation and accurate composition are the important ingredients for a successful painting. Look for the major shapes and colors in the waves, and then carefully study the way waves behave.

Find the principal shapes and lines of the composition and sketch your scene in diluted burnt umber. Consider the shapes the water makes as part of the composition and draw those as well. The details of the concentric ripples in the foreground, for example, add to the pattern of movement throughout the sketch. Then paint a glaze of quinacridone gold to give an immediate sense of space and atmosphere.

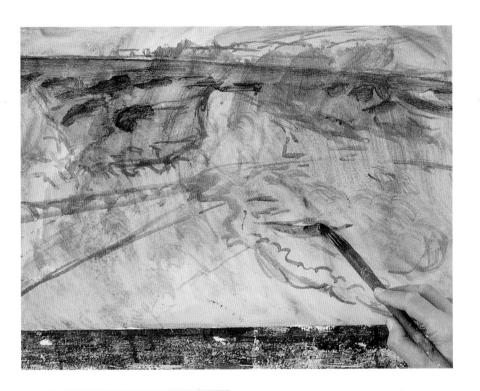

Paint the body of the ocean with varying densities of Prussian blue. This helps set the ocean back into the picture space. Also, because Prussian blue is a transparent color, the gold will show through to create a rich sea green, darkening toward the horizon. Bring some of the sea green into the foreground for the surf near the breaking wave.

PAINTING WATER

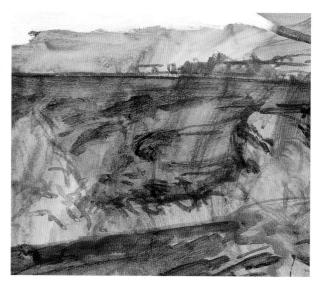

Think about the balance of colors in your painting. You will need to darken the foreground to keep the darkness of the ocean in balance. Paint a glaze of burnt umber in the foreground; then balance again by painting the sky with a thick opaque mix of titanium white, cobalt blue, and burnt umber.

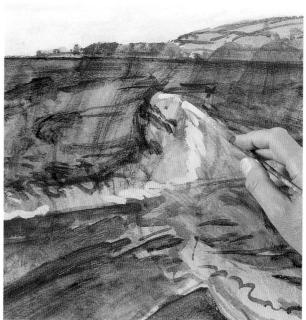

As the waves curl back, they reveal a sparkling underside of pale golden water. Paint this with short strokes of a mix of quinacridone gold and titanium white. Take care not to add too much of this pale opaque tint, or your waves will become leaden and flat.

DEMONSTRATION: WAVES

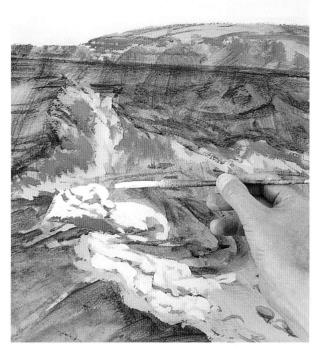

Where the ripples run in from under the wave and across the bottom of the slope, they form a cold froth. Use the same color as the sky to paint the foam. The long-haired fresco brush is perfect for painting these intricate curling lines.

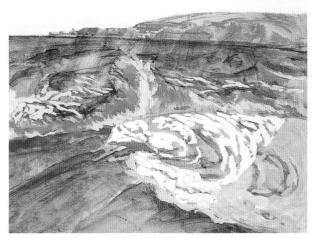

Add more cold blue ripples on the surface of the ocean behind the waves, but with much finer lines. Whenever you are painting, once you have a color mixed on your palette, see if you can use it anywhere else before the paint dries.

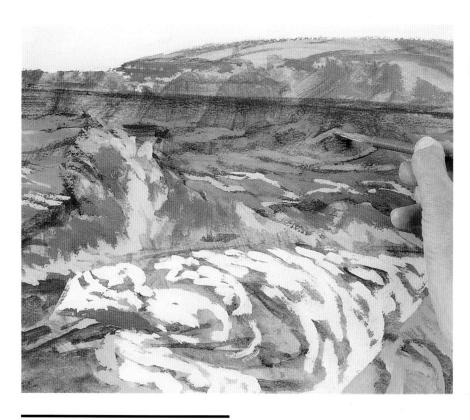

Add more subtle green grays in the ocean behind the waves. Use a cloudier blue gray made from Prussian blue, quinacridone gold, and titanium white to give the distant ocean a more textured, undulating surface.

DEMONSTRATION: WAVES

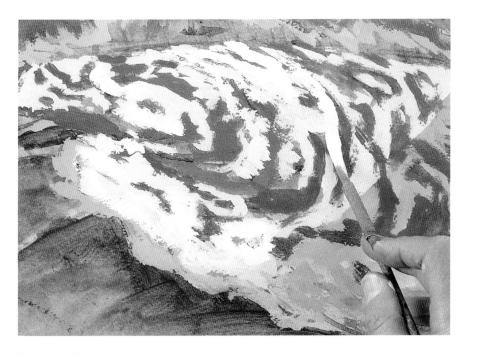

Use a paler mix than before to add shadowed ripples into the lighter ripples to make a richer froth. Keep a significant amount of the darker color to represent seawater without froth to maintain the contrast between the two.

PAINTING WATER

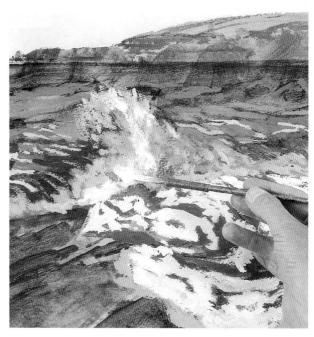

Carefully study the shapes and tones of the area linking the bottom of the wave to the place where the spreading ripples begin. Notice that there are a couple of shapes just darker than mid-tone grays. Paint these with a mixture of Prussian blue, quinacridone gold, and titanium white.

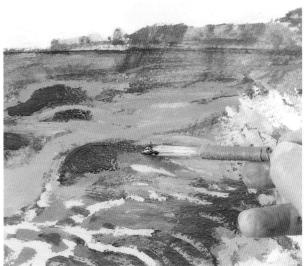

Now the swelling forms of incoming waves need to be refined as shapes and their color deepened. Use Prussian blue as a deep glaze that still permits a little of the gold to influence it. Prussian blue is a greenish blue, so it works very well with the existing greens and blues of the ocean.

DEMONSTRATION: WAVES

The central band of ocean and the right-hand corner of incoming water are more or less completed. Now it is important to consider the foreground to ensure that it does not compete with the breaking wave for attention.

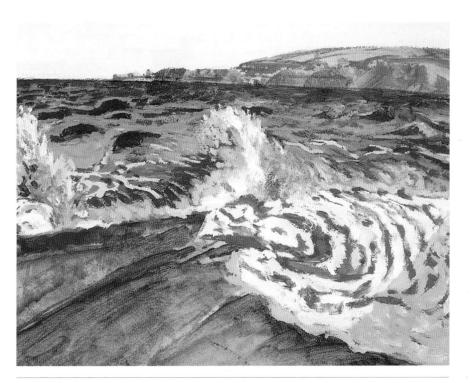

PAINTING WATER

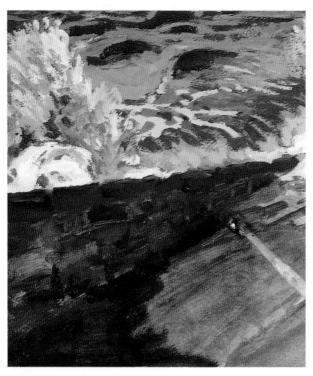

The wet ground in the foreground is quite dark and murky, similar in color to the wall. Use closely related tones from a basic color mixture of permanent rose and Payne's gray. Both are transparent colors making a warm dark glaze, distinct from the cold dark areas of Prussian blue. Paint with loose strokes and a relatively dry brush so the foreground remains texturally distinct from the ebbing water.

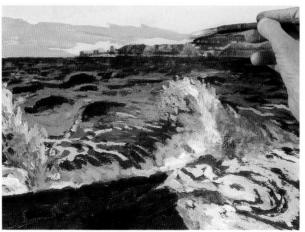

The sky is very flat, so add some darker gray to trap the lighter areas of color as clouds. Use the same colors as the pale layer but with less titanium white. Make your strokes quite free and not uniform so as to mirror the undulation of the ocean and contrast with the receding land line.

DEMONSTRATION: WAVES

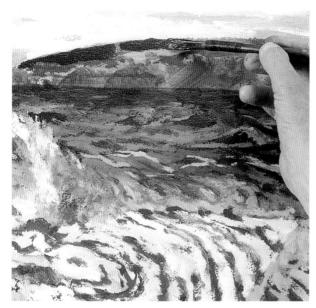

Prussian blue has been a mainstay for much of this picture. Use it again, slightly diluted with water this time, to paint the trees on the distant hill.

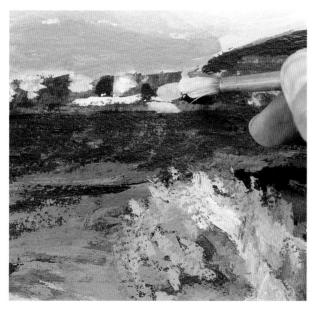

You will find that the gold underpainting is useful when you paint the town on the spit of land and on the hill. Use cool and warm tints of color: titanium white with a little cobalt blue for the cold, and with a little quinacridone gold for the warm. Let the underpainting show, but tone it down in places with a thin wash of Prussian blue to balance it with the rest of the painting.

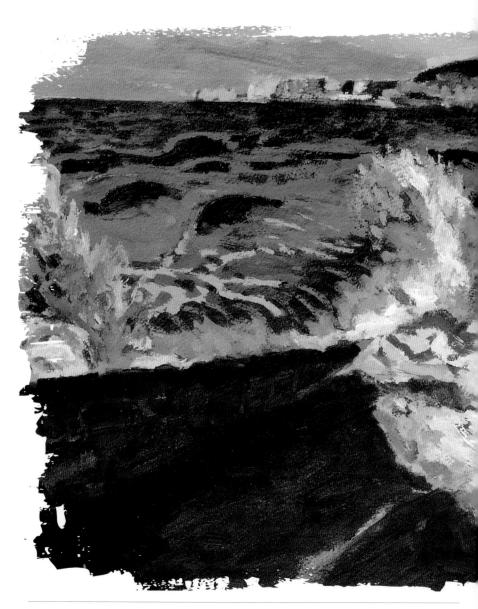

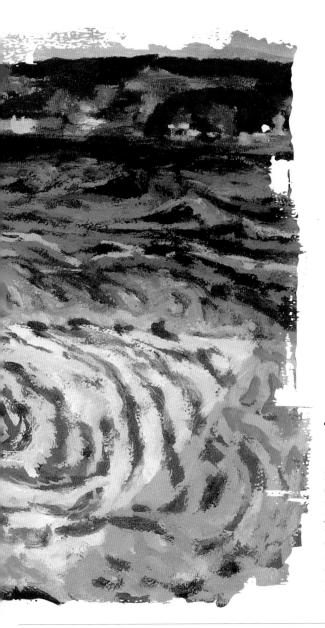

The completed painting has involved a very limited palette, with the dynamism coming from the brush strokes and the juxtaposition of light and dark. The importance of the underpainting is obvious both in the estuary's muddied waves and in the distant buildings, and it serves to unify the painting.

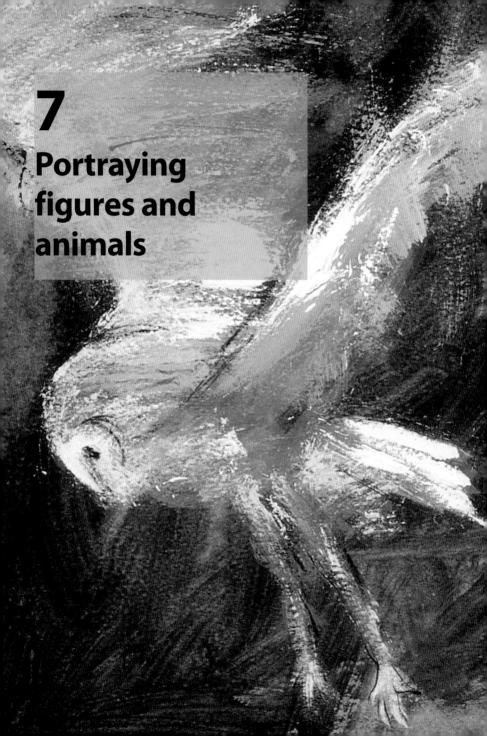

igure painting and portraiture can be difficult subjects for a painter. Because we are all too familiar with the human form, any oddity will be immediately apparent.

Self-portraits are a good way to begin portraiture. You are your own most reliable model, and starting with charcoal or pencil will help you to familiarize yourself with the process of looking before you attempt to paint. A good way of gaining confidence is to take a photograph of yourself, preferably in the space that you will be painting in, and start your painting by drawing from the photo.

Some of the most basic mistakes in figure painting and portraiture are caused by assumptions. Novice painters assume that faces are symmetrical—that a pair of eyes will

be identical or that both sides of the nose are the same. Careful observation will show you just how infrequently you see a truly symmetrical face in the real world.

Animals are notoriously uncooperative models, but they are very good subjects for practicing quick sketching. A sleeping cat can usually be relied on to stay still long enough for a relatively lengthy drawing, but often you will need to paint animals from photographs. Studies of an animal's bone and muscle structure will give you good insight into the shapes they create both in motion and at rest. Just as you would consider the elements of a still life, consider how the shapes of the head, body, and limbs interact with each other.

Capturing the natural color of lips

Too often lips disappear into the face or look too bright and red to be natural. Keeping the lip color subtle but maintaining the importance of the mouth on the face can be challenging. Once again, the trick is to first see the object as an integral part of the whole and then to build the color gradually.

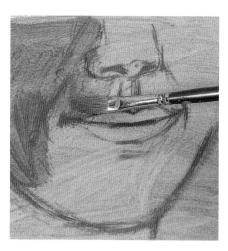

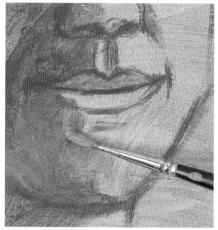

Create a yellow ground with a mixture of yellow ocher and cobalt blue. Then sketch with a mixture of cadmium red deep and titanium white to create a mid-tone base for a Caucasian portrait. The emphasis in any portrait should be on integration. The color and tone of the mouth is integrated with the rest of the face.

Make the lips prominent by adding a shadow with a mixture of cerulean blue, yellow ocher, and titanium white. Scumble the color on so that it acts as a glaze, modifying the previous layers without entirely covering them. This is more subtle than adding color to the lips, but just as effective.

CAPTURING THE NATURAL COLOR OF LIPS

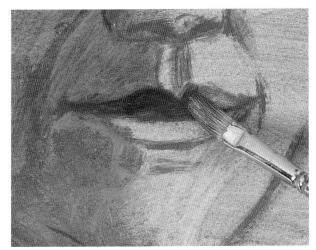

This face is lit from above, so the light source is higher than the model. The upper lip is in relative shadow, and the lower lip is lighter. Brush in the darker tone with a mix of cadmium red deep and cobalt blue. This will enhance the three-dimensional look of the mouth.

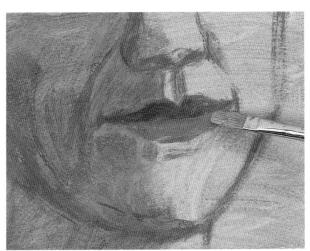

The lower lip is a much warmer and T lighter hue, as the light is hitting it directly. Using a mix of cadmium scarlet, cadmium red deep, and titanium white, apply the color smoothly with your brush.

PORTRAYING FIGURES AND ANIMALS

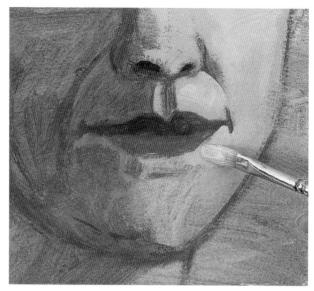

For the illuminated side of the face, you need a light flesh tint. Using a mix of cadmium scarlet, cadmium red deep, and titanium white, start to paint the light side of the face. If the color looks too dark, add more titanium white. Paint slightly unevenly, allowing areas of the underpainting to show through to create the subtle changes in tone.

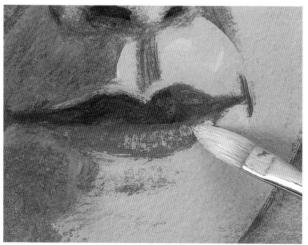

In this close-up, we can see very clearly how the light and shadow side of the philtrum and the light rim of the upper lip catch the light. To reproduce the light on the lower lip, lightly brush on some of the flesh tint previously used on the illuminated side of the face.

CAPTURING THE NATURAL COLOR OF LIPS

artist's note

A useful further study would be to attempt a mouth that was partly open. This would subtly alter the colors, as the whiteness of the teeth and the darkness of the interior of the mouth would need to be considered.

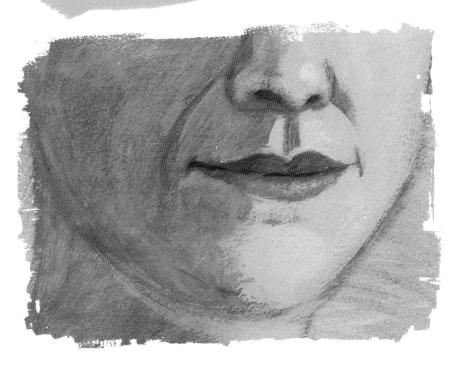

The end result of this study is a mouth seen as a whole. It curves gently around, following the shape of the face and is slightly less visible where it is farther away. The light and shadows establish the forms of the lips. If they were the same color and tone, they would look flat and artificial.

Expressive eyes

We attach a lot of value to the depiction and expression of the eyes. But much of a person's expression is actually visible in the areas around the eyes—in the creasing at the corners when we smile or frown or in the position of the lids and eyebrows. The eyes confirm the signs visible elsewhere.

If you look at a head from a slightly oblique angle, the shape of the eyes will change radically. A three-quarter view will mean that the iris will no longer look perfectly round. The nose will get in the way of one eye and will conceal the nearest corner, and we will see the hooding

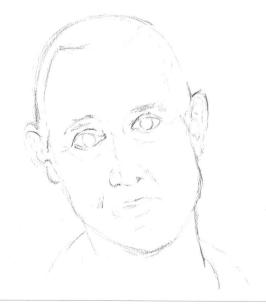

Quickly sketch in an outline of the head with a 2B pencil.
There is no need to put in a lot of detail to the eyes at this stage. Just draw the lids, the shape and size of the iris, and the tear ducts at the corners near the nose. The head is at a tilt, so make sure that the corners of the eyes, nearest to the nose, are at the same angle as the angle of the mouth.

of the upper eyelids more strongly. From the front, we might notice that one eye is bigger than the other, a common occurrence. It is also important to make sure that the corners of each eye are at the same level on either side of the nose.

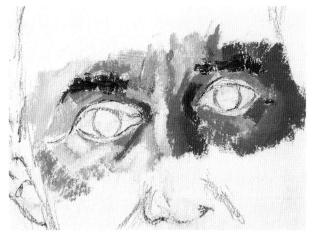

With little dabs of flesh-colored paint made from varying amounts of orange, titanium white, and Payne's gray, begin to construct the planes and creases of the skin around the eyes.

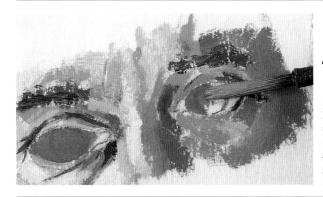

Paint the eyelids using the same three colors, observing how the light is affecting the form. Then smoothly paint in the eyeballs with an underpainting of olive green, titanium white, and Prussian blue.

The whites of the eyes are never pure white. Using a mix of titanium white and Prussian blue, apply the paint unevenly to suggest a slight shine. Then carefully paint the edge of each iris with Payne's gray.

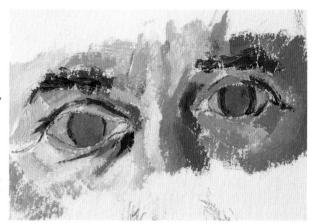

Paint the pupils with a more concentrated Payne's gray, which is virtually black. Then add the highlights to the iris with diluted titanium white. Do not make it too sharp, or you will lose the gleaming shine of the eyeball color.

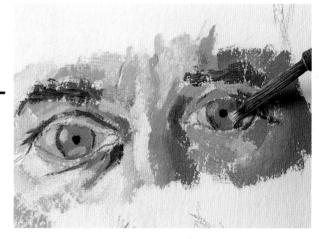

artist's note

If we ever saw anyone who had whites in their eyes that were pure white, they would look very strange. A healthy young person will have slightly bluish whites, an older person will have more pink, and everyone's whites will be affected by the quality of available light.

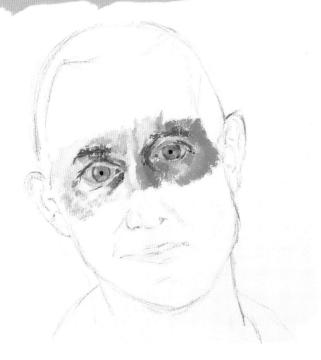

The success of painting eyes is partly judged by whether they sit back in the eye sockets on either side of the nose and under the brows. Common errors by inexperienced painters include making the whole iris visible so that the eyes have a mad, staring expression, and making the distance between the eyebrows and the eyes too great.

Feet and toes

Hands are often thought of as the most difficult feature to draw and paint, but feet present the same kind of problems. Feet change dramatically from one view to the next, so observing the correct proportions of the toes relative to the rest of the foot and ankle is crucial. The shadows, creases, and stance of the feet should also be carefully noted.

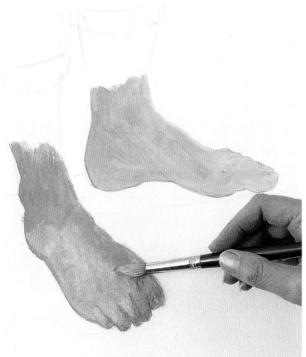

To make the feet look as if they are standing on flat ground, it is important to carefully observe where each heel is relative to the other foot. Carefully observe the position of the feet and sketch them in with pencil. Then apply an underpainting for each foot with yellow ocher. Using a mix of red oxide and titanium white, start to paint in the flesh color of the feet.

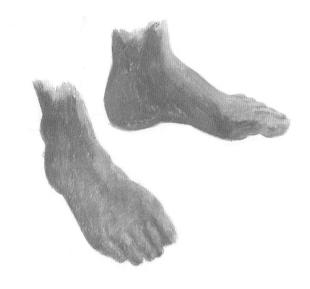

It is important to consider the feet individually and as a pair. Here, the left foot is more in profile than the right one; the toes are hidden behind the big toe, and the curve of the instep is pronounced. The nearer foot presents more of the broad top surface, with the toes and the ankle bone clearly visible.

Next paint the cast shadows. These were cast by a strong artificial light, so the color cast on the white floor is quite blue-mixed from indigo blue, red oxide, and titanium white. Gradually build up the depth of color so that the shadows do not overpower the feet.

Paint darker shadows closest to the left foot and under the arch. with more indigo blue in the mixture. This gives the impression that the heel is firmly planted on the ground. Heighten the light on the top of the feet with a mixture of red oxide, titanium white, and a hint of raw umber to show the intensity of the light and develop the three-dimensional appearance of the feet.

Toes are never uniform, so study each one carefully. Define each toe shape by painting the areas of shadow between them using a mixture of raw umber, titanium white, and a touch of indigo blue. Add a lighter flesh color to the light-facing surfaces of each toe and an even lighter color to the toenails, but do not make them too stark.

In the completed study, we can see how subtle the light and shadow has become. Pale light is reflected up into the instep of the left foot, just above the line attaching it to the ground. This gives it height without making the foot seem to float in the air.

The texture of short fur

Many beginners have a natural feel for the loose texture of shaggy fur on animals. The fur can cover a multitude of details in body shape and muscle definition, making the animal simple to depict. Short fur, however, offers no such help and instead emphasizes the variety of texture, color, and shine on an animal's coat.

It is crucial not to make the fur look hard, like porcupine quills, or smooth, like cloth. Rather than rendering each individual hair, suggest the bulk of the fur in soft masses, picking out details in texture with brush strokes and color changes rather than with many repetitive lines.

Draw the outline of the subject in a color matching the midtone color of the animal's fur. This profile view was drawn with a mixture of diluted raw umber and white. The outline does not need to be darker or stronger: the intention is that it will disappear under subsequent layers of paint. Once you have your drawing established, choose a mid-tone color for the underpainting. Then you need only concentrate on painting the lights and darks.

THE TEXTURE OF SHORT FUR

Block in the whole animal with an underpainting to establish the mid-tone of the coat. Use a much paler mixture to scumble the "white" patches on the dog's head. Stroke only a thin, translucent white on the ears, compared to the relatively heavy application on the side of the jaw. Capturing the varying density of the hair color is the key to making the coat realistic.

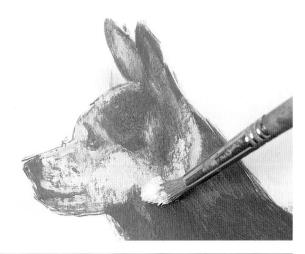

Paint the dark patches of the dog's hair with ivory black, not uniformly, but following the range of tones visible in the coat. The underpainting shows through the black where it is painted thinly in places on the coat. Paint the nose solidly black, except for the highlight, which gives us the healthy shine.

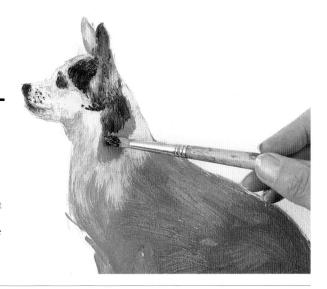

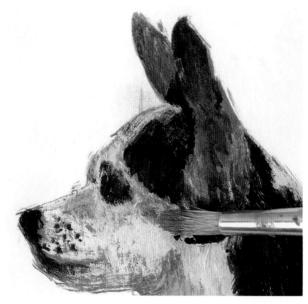

Next, apply raw sienna. It is an ideal, transparent sandy color for warm sable hues. Where it is applied thickly, the color is quite a rich orange-yellow; where it is applied thinly, the undercolor lightens or darkens it, respectively.

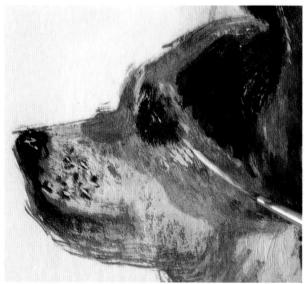

Add white highlights and some stray white hairs using a fine rigger brush to complete the natural look of the dog's coat. Stipple in the black spots next to the nose with the end of a round hog brush, but be careful to keep the definition of the spots.

THE TEXTURE OF SHORT FUR

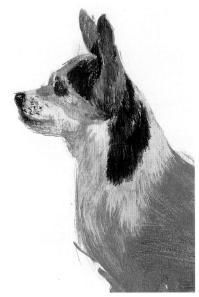

Where the light falls away underneath the head and down the neck and chest, use a darker raw umber and titanium white mix. Make sure the edges of the patches are not too hard so they do not break up the solidity of the form.

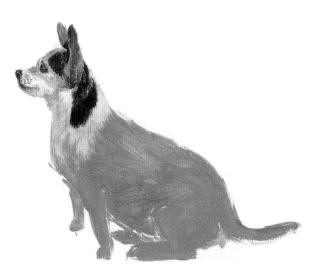

The unfinished study shows how useful the raw umber and titanium white underpainting is. It acts as a tonal and color reference as well, providing solidity to the subsequent layers.

Capturing the sense of an animal's movement

Making a static picture suggest movement is an exciting challenge. The decision is whether to paint precise, correctly anatomical movement or merely an impression of movement. The anatomical approach can still create a static painting; however, a freer impression can be extremely effective and powerful. It is the drama of the movement that is captured, rather than a photographic representation of it.

Paint a base with a thin wash that will allow your subject to stand out. Here, a wash of indigo blue was covered with a scribble of a mixture of cadmium red medium and indigo blue before it dried. Add a little titanium white to the mixture for the sketched outline.

Use the same gray made from cadmium red medium, indigo blue, and titanium white to brush in the full shape of the owl. Already the brush marks suggest movement, especially with a ragged edge on the wings.

Choose a striking image, but do not paint too tightly. Much of the expression of movement will be captured in the way you form the brush strokes. Keep your arm and wrist movements fluid, and think of the picture as a whole as you paint.

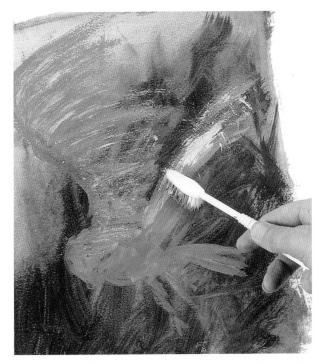

To prevent the shapes from becoming too precise, brush on a lighter color (more titanium white in the mixture) using an old toothbrush. To maintain lightness and a sense that the bird is not frozen in one place, it is important neither the wings, nor the body, appear too solid.

PORTRAYING FIGURES AND ANIMALS

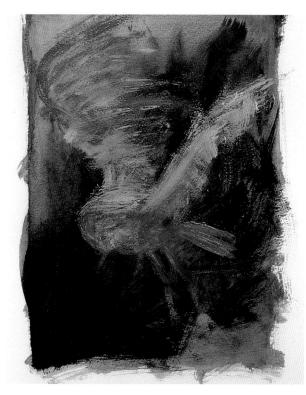

Still using the toothbrush, roughly apply a mix of raw sienna and titanium white to the wings and the top of the head. In places, score through the color with a sharp brush handle to add to the sense of momentum and transience.

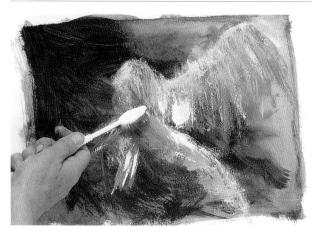

Add coarse strokes of titanium white with the toothbrush for the lightest flashes on the wings and tail. Apply the paint more thickly on the near edge of the left wing, but use loose, scratchy strokes to maintain the overall lack of precision.

CAPTURING THE SENSE OF AN ANIMAL'S MOVEMENT

artist's note

The only practical way to depict figures in motion is to paint from photographs. Select images without too much background detail to distract you from the figure, and don't get too caught up in specific details.

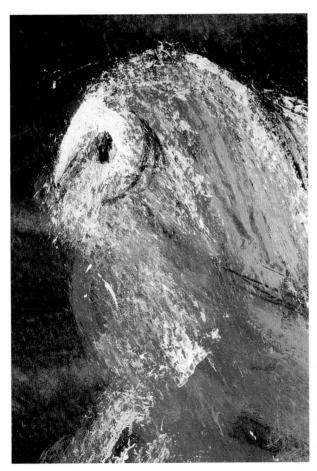

For the head—the area of clearest detail in the painting—use a more solid application of paint and delineate the eye and edge of the face with fine black lines.

PORTRAYING FIGURES AND ANIMALS

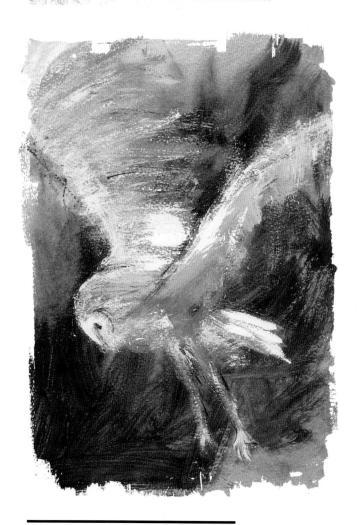

In the finished study, you see a ghostly barn owl passing through the twilight, even though there is no polished definition of form. The dark brush strokes in the background interact dynamically with the lighter flashes of the wings, and each of these contributes to the overall impression of movement.

Acrylics suppliers

The stores listed below are all happy to supply via mail order—and some have retail stores, too.

United States

MisterArt 913 Willard Street Houston, TX 77006 800-721-3015 www.misterart.com

Jerry's Artarama PO Box 58638J Raleigh, NC 27658 800-827-8478 www.jerrysartarama.com

McCallister's Art Supplies 300 Salem Avenue Dayton, OH 45406 888-419-6615 www.mccallisters.com

Pearl 1033 East Oakland Park Boulevard Fort Lauderdale, FL33334 954-567-9678 www.pearlpaint.com

United Kingdom

T.N. Lawrence and Son 208 Portland Road Hove BN3 5QT 0845 644 3232 www.lawrence.co.uk

Ken Bromley Art Supplies Curzon House Curzon Road Bolton BL1 4RW 01204 381900 www.artsupplies.co.uk

Art Discount
Graphics House
Charnley Road
Blackpool
Lancashire FY1 4PE
0845 230 5510
www.artdiscount.co.uk

Index

Entries in italics indicate completed works detail 110-13, 126, 133, 147, 186, 204, 212 illustrating techniques. drawing 15, 26-7, 42, 92, 123, 182, 199, 204 Α alla prima 10 E animals 198-220 equipment 7-8, 101 atmosphere 106, 108, 146, 177 creating 132-75 F faces see also portraits B eyes 204-7 brickwork 172-5 lips, mouth 200-3 brushes 7, 8, 16-19 feet 208-11 figures 159, 162-3, 103, 198-211 (fingers, using 20-3, 147-8, 170, 177 charcoal 26-7 fixative 10 Chardin, Jean-Siméon 75 flowers 60-73, 92-5, 110, 112 clouds 138-41, 177, 182-5, 194 folds 84-7, 92 color foliage 114-17, 118-22, 128-9, 142 blending 54-5 format 24-5 mixing 47, 60-1, 63-73, 94-5 landscape 24-5 spectrum 20-3 portrait 24-5 understanding and using 46-73 fur 212-15 wheel 47, 48-9 colors G complementary 10 glass 88-91 primary 12, 47, 48-9, 50 glaze 10, 56-9, 67, 167, 168, 186, secondary 12, 48-9, 50-1 188, 192, 194, 200 tertiary 13, 50-51 gradation 10 composition 10, 26-27 ground 10, 31-5 Constable, John 101 foreground, middle, and background, Crimson ground 35 uniting 102-5 D Н De Chirico, Giorgio 75 Hélion, Jean 9 demonstrations 63-73, 123-31,

Hockney, David 9

153-63, 186-97

Hoyland, John 9	perspective 11, 42-5, 138
hue 11	aerial 10
	atmospheric 123, 124, 140, 156
1	linear 11, 42-3, 106
impasto 7, 9, 11	one-point 11, 43
Impressionists, French 101	three-point 44
	two-point 44
L	Picasso, Pablo 75
landscapes 24-5, 101-31	pigments 6
leaves see foliage	portraits 199, 200-3, 204-7,
Léger, Fernand 168	Precisionists 168
light, lighting 76, 80-1, 84, 89, 101, 118-19,	priming 9
87, 133, 153, 168-9, 172, 174, 177, 178, 180,	
182, 184, 199, 201-3, 205, 207, 209-11, 215	R
Louis, Morris 9	reflection(s) 88-9, 96-9, 136, 177, 178,
	182-5
M	retarder 6
machinery 168-71	Riley, Bridget 9
mahl stick 7, 11	ripples 177, 178-81, 189, 191-2
media 6	
medium 11	S
metal 77, 96-9, 168-71	scumble, scumbling 12, 34, 165, 168,
mist 146-8	172-5, 200, 213
movement, capturing 216-220	sea 106-9, 177, 186-97 see also water
	sgraffito see techniques
N	shading, shadow(s) 36-7, 77, 78,
negative shapes 38-41	80-3, 84-7, 91, 101, 131, 133, 134-6, 138,
	140, 146, 168-9, 174, 177, 200, 201, 202,
O	208–11
oils 6	Sheeler, Charles 168
owl (movement) 216–220	silkscreen printing 9
	sketchbook 15, 28-30
P	sketch, sketching 15, 26-7, 28-30, 60, 88,
palette, limited 171, 197	92, 96, 118, 168, 186, 199, 200, 204, 208,
Pear with glazes 59	216
pencils 28	

sky 102-3, 120, 110, 125, 127-9, 137, 138, 148, 149, 177, 182-3, 194 snow 149-63 spattering 12, 22-3 sponging 12, 20-1 stenciling 9 still life 74-99, 172 stippling 12, 82, 161, 214 sunlight 134-7, 163, 181

Т techniques basic 15-45 sgraffito 12 wet-into-wet 13 temperature 133 texture 13, 20-1, 79, 82, 121, 132-75, 177, 190, 212-15 Thiebaud, Wayne 9 tint 13

tone 13 trees 114-17, 118-22, 123, 128-131, 148, 149-52, 156, 157, 163, 184, 195 Turner, J.M.W. 101

vanishing point 9, 26, 27 viewfinder 9, 16

W Warhol, Andy 9 water, painting 176-97 watercolor 6 waves 186-97 weather 133, 177 wet into wet see techniques white, problems painting 153 wind 142-5 wood 164-7